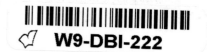

Western Ways

IMAGES · OF · THE · AMERICAN · WEST

BY BRUCE I. BUSTARD

AN EXHIBITION AT THE

NATIONAL ARCHIVES AND RECORDS ADMINISTRATION

WASHINGTON, DC

OCTOBER 9, 1992, THROUGH OCTOBER 17, 1993

Published for the
National Archives and Records Administration
By the National Archives Trust Fund Board
1992

Library of Congress Cataloging-in-Publication Data

United States. National Archives and Records Administration.
 Western ways : images of the American West : an exhibition at the
National Archives and Records Administration, Washington, DC,
October 9, 1992, through October 17, 1993 / by Bruce I. Bustard.
 p. cm.
 Includes bibliographical references.
 ISBN 0-911333-97-5
 1. West (U.S.)—Civilization—Exhibitions. 2. West (U.S.)—
—Pictorial works—Exhibitions. I. Bustard, Bruce I., 1954- .
II. Title.
F591.U586 1992
978'.0074753—dc20 92-21698
 CIP

Designed by Serene Feldman Werblood, National Archives

Cover: **"The Grand Cañon at the Foot of the Toroweap Looking
East,"** by William Henry Holmes, from Clarence Dutton, *Tertiary
History of the Grand Cañon District, 1882.* Holmes's later series of
lithographs of the Grand Canyon drew on his experience as a member
of several western surveys. His renderings are unsurpassed for their
beauty and scientific accuracy.
RG 57, Records of the Geological Survey

Contents

Preface

FOR MOST OF US, the American West holds a special place in our history. Its awesome space, rugged mountains, wide plains, and huge canyons seem to sum up much of what is unique about the geography of our nation. The story of its land and people has absorbed generations of Americans as well as many others around the world. This is not surprising. The history of the West encompasses drama, courage, struggle, and romance.

Yet the study of the West, while continuing to interest us, has changed. It has become more inclusive, embracing women, Native Americans, and other minorities as well as the more traditional images of cowboys, homesteaders, and gunslingers. Western history has also moved away from a preoccupation with the 19th-century frontier and its closing. In short, it has become a longer, more complex, but no less fascinating story.

This complexity is reflected in the remarkable variety of photographs, drawings, maps, and other documents reproduced in this publication. The traditional West is here, but here too are less well known stories: Native Americans; Chinese immigrant workers, who built much of the transcontinental railroad; African-American soldiers on the frontier; and women homesteaders. These represent only a part of the wonderful resources on the West found among federal records held at the National Archives in Washington, DC, and in our Regional Archives System. Over the years, our government has created and collected millions of images that touch on virtually every aspect of life in the West. As caretakers of this material, we at the National Archives are pleased to be able to share some of them with you.

Unless otherwise noted, all items appearing in this catalog are from the holdings of the National Archives and Records Administration and are identified by their record group (RG) number and appropriate citation.

DON W. WILSON
Archivist of the United States

Acknowledgments

THIS PUBLICATION accompanies the 1992 National Archives exhibition "Western Ways: Images of the American West." Both the exhibit and publication were prepared by the Office of Public Programs of the National Archives under the direction of Linda N. Brown, Charles W. Bender, Edith M. James, and Emily W. Soapes. This book was designed by Serene Feldman Werblood of the Development and Production Branch, Publications Division. Special appreciation is also due to Archives staff members Lisa B. Auel, Eileen Bolger, Stacey Bredhoff, Barbara Burger, Dale Connelly, Pat Eames, Stephen Estrada, Henry J. Gwiazda, Jonathan Heller, Elizabeth Hill, Joan Howard, Joyce Justice, Allan Kaneshiro, Janet Kennelly, Robert M. Kvasnicka, Waverly Lowell, Edward McCarter, Earl McDonald, Martha Marselis, Nick J. Natanson, Catherine Nicholson, Susan Page, Marilyn Paul, James D. Rush, Mary C. Ryan, Richard Schneider, Chris Rudy Smith, Richard H. Smith, Jerry Thompson, Brian Tilley, Sandra M. Tilley, Jimma Tufa, Tim Wehrkamp, and James D. Zeender.

Outside the Archives, Professor Paula Nelson of the University of Wisconsin, Platteville, and Rayna Green, Director of the American Indian Program at the National Museum of American History, read the exhibit script and offered many helpful suggestions. Doug Munson of the Chicago Albumen Works prepared many of the reproductions of 19th-century photographs that appear in the exhibit and catalog. We are grateful for their contributions.

BRUCE I. BUSTARD
Exhibits Branch, National Archives

Introduction

THERE IS SOMETHING fascinating about a photograph, drawing, or map depicting the history of the American West. That these should capture our imagination is not surprising. The history of the West is filled with memorable images that have become part of our culture and consciousness. But many of the most well known of these photographs and drawings — whether they are of western landscapes, homesteaders, miners, cowboys, or Native Americans — emphasize the 19th-century frontier experience rather than the entire history of the region. Others have a cast of characters that ignores the diversity of the West's people. Many treat its environment simply as beautiful scenery.

However appealing, these classic images, while capturing the mythic West, give us only a partial picture of Western history. We need to take a closer look — one that takes into account the variety of people who called the West home, that highlights the continuities in its history, and that focuses on how the environment shaped its past and present.

This catalog provides you with an opportunity to take that closer look. It offers 127 images of the trans-Mississippi West, plus Alaska and Hawaii, dating from the early 19th century to the present. Some images are familiar. Some are surprising. Many were created by well-known artists and photographers seeking to capture a historic or telling moment; others were made by unknown individuals recording a scene for undocumented reasons. All demonstrate the significance and spirit of the region's history.

Understanding the western images presented here begins by considering their history, how they were intended to be used, and how they confirm (or do not confirm) our notions of "the West." For the most part, the images are from the holdings of the National Archives. As such, they reflect the federal government's longstanding interest in exploring and developing the West. The products of that interest — photographs, maps, and drawings — came first to the federal agencies that created them and then to the National Archives, which now cares for them as historically valuable government records.

This "federal connection" points out the importance of exploring the role of the government in the West. Since shortly after its creation in 1789, the U.S. government has sought ways to develop and use resources of the trans-Mississippi West. President Thomas Jefferson sponsored the 1804–6 Lewis and Clark expedition across the Northern Plains and the Pacific West. In the 1850s the U.S. Congress directed the Army Corps of Topographical Engineers to survey the West for possible transcontinental railroad routes. Acts of Congress also gave homesteaders free land in the West, granted rights-of-way to railroads, and built the West's vast system of dams and irrigation canals.

But why should the federal government care to photograph, draw, or paint the West and its history? The answer, in many cases, is quite straightforward. Dependent upon Congress for funding, the President for direction, and the public for support, federal agencies had a great stake in documenting their successful, or even failed, programs and projects. This government documentation helped Americans in the East to see the wonders west of the Mississippi that they could otherwise only imagine. Thousands of words could be written, for example, about the security of the mails in the West, but a photograph of a well-guarded stagecoach was quicker proof. Surveyors and scientists might write volumes on the geology of the Grand Canyon, but William Henry Holmes's lithographs allowed the reader to sit on the canyon's rim.

Nineteenth-century reports, investigations, and other publications on the West routinely included drawings, lithographs, watercolors, or photographs. President Jefferson instructed Lewis and Clark to delineate "the face of the country" during their travels. When they returned 2 years later, they delivered maps, sketches, and natural history specimens to the door of the President's

house. The 13-volume Pacific Railroad Survey report contained lithographs of the geography surveyed, the plant and animal life discovered, and the native cultures encountered. Members of George Wheeler's western surveys assembled bound volumes of William Bell's and Timothy O'Sullivan's survey photographs, which were then presented to Members of Congress and other influential individuals thought to have an interest in the future of the West.

As more western lands came under U.S. control through treaties, annexations, and wars, federal agencies, bureaus, and departments moved west. One of the earliest and most active of these was the U.S. Army. In the mid- to late 19th century, the Army played a vital role throughout the region, protecting settlements, building roads, and manning a farflung system of forts. As a result, the photographs among Army records at the National Archives touch on almost every aspect of life in the West. There are, to be sure, photographs of post parades, the aftermath of battles, and troops guarding stagecoaches, but there are also photographs of cattle roundups in Kansas, miners in Dakota Territory, town life in Alaska, and ranching in Hawaii.

Civilian agencies also created vast photographic files. Bureau of Indian Affairs records, as well as those of other agencies, tell the shameful story of the betrayal and conquest of western tribes, the destruction of traditional forms of Native American life, and the federal efforts aimed at forcing American Indians to adopt Euro-American ways. But they also document the later 20th-century renewal of Native American government structures, arts, religion, and culture — renewal that was often assisted by government programs. Tribal arts, culture, and religion are seen in a more positive light in more recent photographs, and even Native American protests against the government are sometimes pictured sympathetically.

Images made their way to the National Archives not only through agency documentary efforts but by way of the judicial or investigative process. Court cases, hearings, and other governmental investigations produced voluminous case files of information on subjects as diverse as immigration, natural resources, labor disputes, and commerce. When a Chinese woman sought to stay in Hawaii by proving the American citizenship of her children, she included a portrait of her family along with other evidence. When the federal government sought to stop construction of a pipeline across Mono National Forest in California in 1910, it submitted photographs to the courts as evidence of the damage done by construction. The 1915 Commission on Industrial Relations considered photographs of labor violence in the aftermath of a miners' strike in Ludlow, Colorado.

Congress, too, used drawings and photographs in its work. Lucien Turner's notes on the "Natural History of Alaska," presented to Congress in 1886, contained Robert Ridgeway's marvelously detailed paintings of Alaskan birds. A Senate investigation of the 1906 San Francisco earthquake included maps of the city and photographs of the damage. The Oklahoma railroad bill, which was passed by the House in 1894, called for towns seeking stations along proposed routes to prove they were viable. Round Pound, Oklahoma, and several other municipalities along the proposed route sent photographs showing thriving saloons, hotels, banks, restaurants, and drugstores.

THOUGH IT IS CLEAR why many images of the West are in government records, the reasons for the existence of other images are not readily apparent. The intent of federal mapmakers, artists, and photographers was not always simply to record the workings of an agency and its programs. Maps of Yellowstone done by government surveyors, for example, are the direct result of a federal undertaking. But why did photographers employed by the Bureau of

Reclamation move beyond photographing the stages of dam and ditch construction and shoot schools, celebrations, farms, and streetcars? Why has the federal government, during more recent times, funded documentary photography seemingly unrelated to a specific building project or agency task? And why are photographs of 19th-century homesteaders and western towns among the records of the Work Projects Administration, a New Deal agency of the 1930s?

To a great extent, the answer lies in the expanding role of government during the 20th century, growth that was particularly noticeable in the American West. Early Bureau of Reclamation photography, for instance, documents construction, but it also documents the zeal with which advocates of reclamation within the bureau approached their task. For these individuals, making arid lands bloom was a mission. More usable land meant greater opportunity: opportunity for building model communities, opportunity for new markets in the West, and opportunity for "landless" city dwellers to make a new life.

Reclamation Bureau photography reflects this sense of mission. In these photographs, government action is a force for change. Settlers wait years for the promise of water. The completion of an irrigation project brings celebration. After the transformation, towns grow, schools are built, and families prosper. Each completed project brought progress to the West, and government photographers tried to demonstrate that irrigation could "reclaim worthless lives along with worthless desert soil" and encourage more settlers to move west.

The Great Depression challenged this notion of progress. In the West, the economic catastrophe of the 1930s was matched by an ecological one. Across the Great Plains, several years of drought, assisted by overcultivation and poor soil conservation, created huge duststorms that blackened the sky and made residents into refugees. The federal government responded with a host of programs designed to save the economy and the land. It also sent agency photographers to the West to document both the devastation and the government's response. Dorothea Lange, Irving Rusinow, Rondal Partridge, and others made the sad and now familiar images of communities struggling to survive, of Dust Bowl refugees moving across the Plains, and of young people "riding the rails" in search of work. But other government photographs supported a more optimistic view: that New Deal intervention would solve the nation's crisis and solve the very problems the images recorded.

As a wider range of government activity became more acceptable, a number of government-sponsored programs emerged with the purpose of photographing or otherwise creating images. The Interior Department sponsored art relating to the National Parks and reclamation projects. In 1941, for example, Secretary of the Interior Harold Ickes commissioned Ansel Adams to photograph the West for a series of murals. The murals were never finished, but Adams's original photographs eventually came to the National Archives. The Work Projects Administration published guides to the states. For illustrations, the compilers collected photographs from state historical societies and archives. After World War II, the U.S. Information Agency, which promotes our nation around the world, also collected photographs from government, commercial, and corporate sources.

Such programs grew through the 1970s. One of the most significant of these was the Environmental Protection Agency's DOCUMERICA, which hired talented photographers who were charged with "photographically documenting subjects of environmental concern in America." This time their work was done in color, but the DOCUMERICA photographers had close ties to their New Deal predecessors. Project director Gifford Hampshire sought the advice of New Deal photographers Arthur Rothstein and John Vachon, and like New

Deal efforts, DOCUMERICA broadly interpreted its charge. Its photographers recorded not only environmental damage such as smog, clear-cut timber, and urban sprawl, but also Navajo reservation life, San Antonio's Hispanic heritage, and western scenery.

SEVERAL THEMES emerge from a visual history of the West seen mainly through government records. First, the federal presence has loomed large in the West. This interest is apparent when one considers the variety of agencies — from the Army to the National Park Service to the Bureau of Land Management — that have shaped the West. Westerners have not always been happy with this federal attention. They have welcomed federally funded projects such as irrigation canals and power projects, but they have chafed at what they have seen as the invasive influence of federal regulation and bureaucracy. Nevertheless, the federal government, as the images in this catalog demonstrate, left its mark across the West.

Second, the images in this publication show that the environment and our efforts to control it have dramatically shaped Western history. The West's spaciousness was both a challenge and a promise of opportunity for generations of explorers, settlers, and engineers. Its aridity has brought forth mammoth efforts to dam rivers and build reservoirs and has stimulated equally large political fights between supporters of development and wilderness preservation. Reliance on natural resources, such as coal, copper, timber, oil, and even its natural beauty have stoked the fires of the region's economy but have also made it vulnerable to violent boom-and-bust economic swings and ecological damage.

Third, the West was and continues to be one of this country's most diverse regions. The mythic West marginalized the presence of Native Americans and depreciated the influence of other minority groups and women. A fresh look at the region's history reveals it to be a dynamic meeting place for a variety of cultures and peoples. The images in this catalog show that interaction among these groups and the ongoing struggle for community were present in the West from its earliest days.

These themes make a larger point. In our preoccupation with the frontier, with its emphasis on change, we have been blind to the continuities in Western history: struggles among Native Americans and other groups hardly ended at Wounded Knee; the federal presence in the West continues to grow and shape the region's economy; the environment and our efforts to manage it are some of the region's more incendiary political issues. And the West continues to be a culturally diverse region, possibly leading the nation in its struggles to create more inclusive communities. As we look ahead to the West's future, it may be helpful to know that the problems and opportunities it faces — be they political, economic, or environmental — are often grounded firmly in the West's past.

*The problem of the West
is nothing less than the problem
of American development.*

—Frederick Jackson Turner,
"The Problem of the West" (1896)

◆

The West as Home
NATIVE AMERICANS

WHEN EUROPEANS came to the West, they found numerous peoples already living there. These Native Americans had been in the West for thousands of years and had developed different ways of living, depending on their location, climate, and physical and cultural needs. Contact with Europeans brought change, sometimes for the better but more often with disastrous consequences for Native Americans.

Depictions of Native American life were some of our earliest images of the West. Many western tribes have rich traditions of picturing the land and important events such as battles, gatherings, and famines. Throughout the 19th century, white artists and photographers documented native cultures on government-sponsored explorations of the West. In the early 20th century, government photographers recorded efforts to remake native cultures in the white man's image. In more recent times, agencies such as the Bureau of Indian Affairs, the Environmental Protection Agency, and VISTA photographed Native American life. Many of these photographs, as well as images by tribal peoples themselves, have found their way into the records.

Pueblo couple in their home, ca. 1920, by an unknown photographer.

RG 75, Records of the Bureau of Indian Affairs, United Pueblo Agency, General Superintendents File, National Archives–Rocky Mountain Region

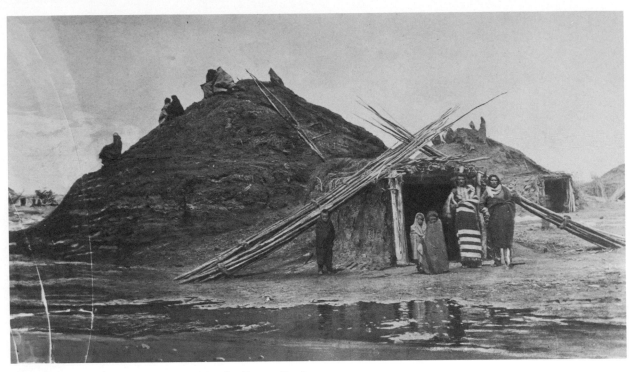

"Pawnee lodges at Loup, Nebraska, with a family standing in front of a lodge entrance," ca. 1871, by William Henry Jackson. Most Plains Indians were nomadic and lived in tepees, but some, such as the Mandan and Pawnee, constructed earth lodges as dwellings.

RG 106, Records of the Smithsonian Institution (106-INE-3)

"Wupatki National Monument, Arizona," January 1980, by Tom Till. The 800 pueblo ruins at Wupatki testify to a Native American presence in the American Southwest dating back to 1100 A.D.

© *Tom Till*

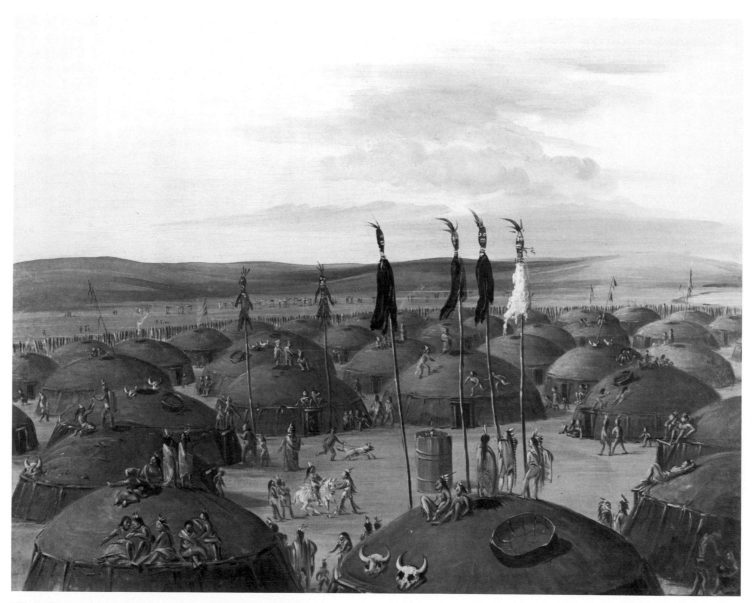

"Bird's-Eye View of the Mandan Village, 1800 Miles Above St. Louis," 1837–39, by George Catlin. On several trips to the West, artist George Catlin painted Mandans, Pawnees, and Comanches. His paintings contain important ethnographic details, but Catlin also stylized and romanticized Native American life.

Courtesy of the National Museum of American Art, Smithsonian Institution, Gift of Mrs. Joseph Harrison, Jr.

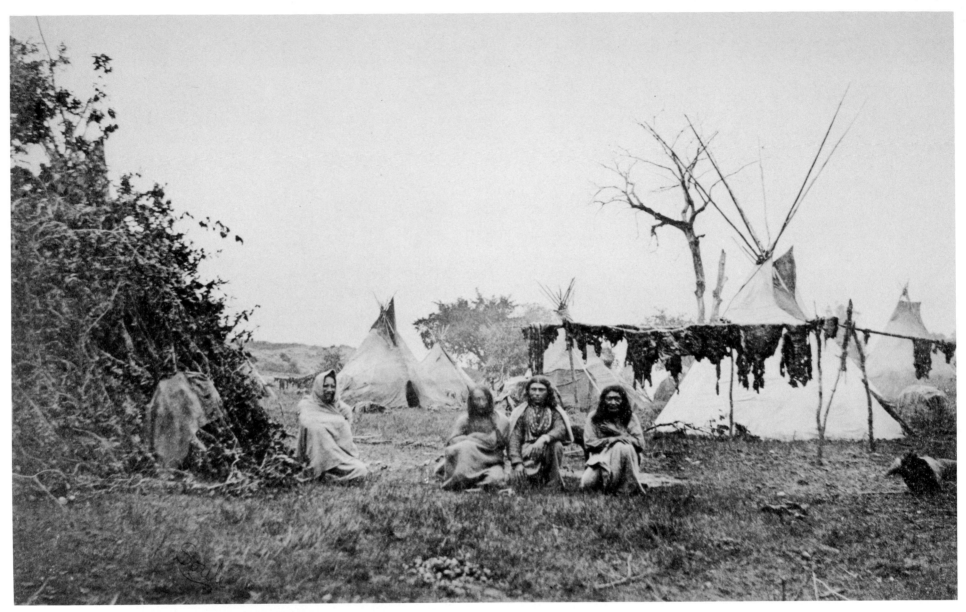

Arapaho camp with buffalo meat drying near Fort Dodge, Kansas, 1870, by William Soule. Many Plains tribes, such as the Arapaho, were migratory hunters who depended on the buffalo for food, shelter, and clothing.

RG 75, Records of the Bureau of Indian Affairs (75-BAE-48c)

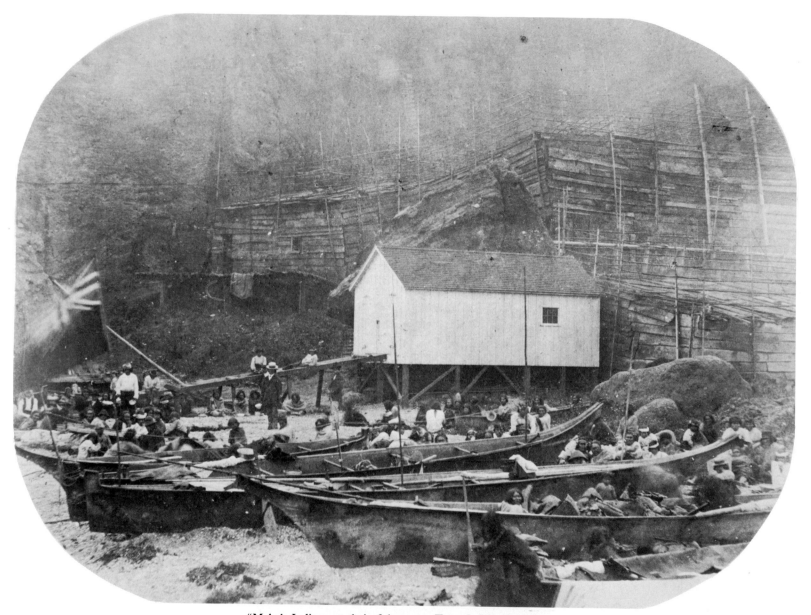

"Makah Indians at their fishery on Tatoosh Island at the entrance to Straits of Fuca, Neah Bay Agency," Washington, ca. 1895, by Huntington Brothers. This photograph shows the contrast between native and Euro-American ways. A traditional Makah plank house stands behind a more modern wooden structure. The boats are native dugouts, one flying the British naval ensign, and the Makahs wear both traditional and European clothing.

RG 75, Records of the Bureau of Indian Affairs (75-IP-1-53)

"Old Kasaan, Alaska," ca. 1900, by an unknown photographer. Native Alaskans and Native Americans of the Pacific Northwest organized their societies around family or clan, tracing their lineage to ancestors who were part animal and part human. Totem or house poles, carved cedar tree trunks bearing the likenesses of these ancestors, were placed inside or outside homes as memorials, as a way of storytelling, and as an indication of family lineage.

National Archives Donated Materials, Henry S. Wellcome Collection, National Archives–Alaska Region

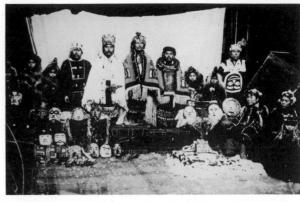

"Ceremonial assemblage of Indian shamans of high rank," ca. 1900, by an unknown photographer. This photograph may have been taken at a potlatch, a ceremonial feast among Pacific Northwest tribes where the host's prestige is determined by the gifts he bestows on his guests. Believing that the practice did not encourage thrift, American and Canadian governments banned potlatches, confiscating most potlatch paraphernalia and turning it over to museums.

National Archives Donated Materials, Henry S. Wellcome Collection, National Archives–Alaska Region

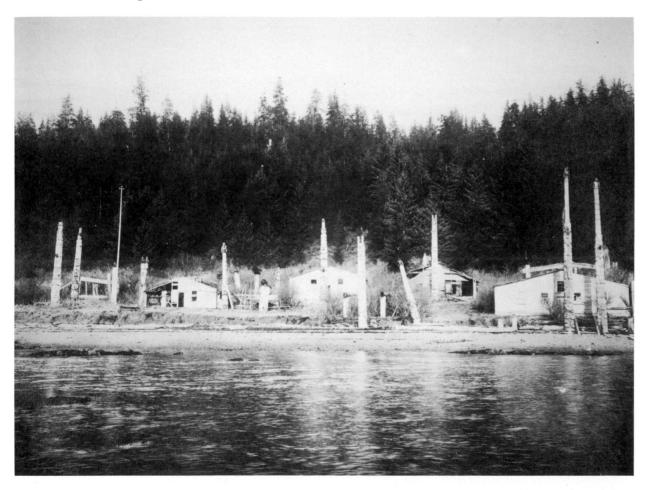

CONFLICT AND CHANGE

INTERACTION between whites and Native Americans in the West increased dramatically throughout the 19th century. Some of these dealings, ranging from trading to intermarriage, were friendly. But as more soldiers and settlers came west, the potential for misunderstanding and conflict grew along with competition for land, food, and other resources. Federal policies contributed to this conflict: Treaties were made and then broken, tribes were removed from their homelands, and white squatters were allowed to settle on Indian lands. For Native Americans, these actions threatened to destroy their ways of life. Often they responded with armed resistance.

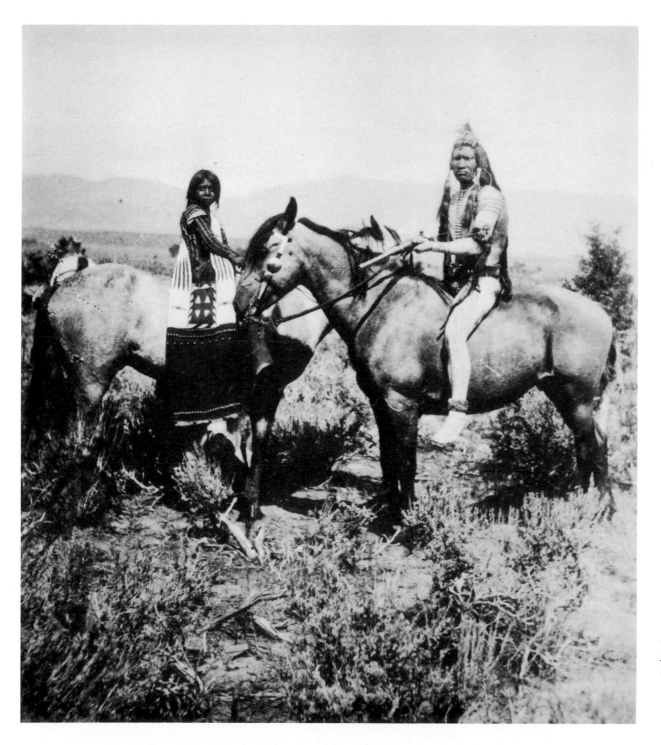

"Ute Warrior and boy at the Uintah Agency," northeastern Utah, July 20–26, 1871, by E. O. Beamon.
RG 57, Records of the Geological Survey (57-PE-110)

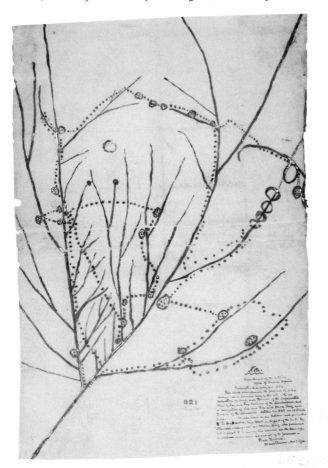

Map of the Mississippi River Valley drawn by Iowa Chief No Heart, 1837. This map was drawn in conjunction with treaty negotiations with the Iowas in 1837. It depicts trails, villages, rivers, streams, and tribal boundaries.

RG 75, Records of the Bureau of Indian Affairs, Central Map File #821

"**Register of Indians who have emigrated to the West of the Mississippi,**" 1834. The Indian Removal Act of 1830 tried to solve the problem of conflict with Native Americans and provide more land for white settlement by authorizing the removal of eastern tribes to lands west of the Mississippi River. The forced removal of five southeastern tribes — the Choctaw, Cherokee, Chickasaw, Creek, and Seminole — was especially devastating. Each faced shortages of food and clothing, and many died of exposure, hunger, disease, or at the hands of bandits along the way. Estimates of Cherokee deaths during their 800-mile journey, popularly called the "Trail of Tears," run as high as 4,000.

RG 75, Records of the Bureau of Indian Affairs, Cherokee Muster Rolls, vol. 1

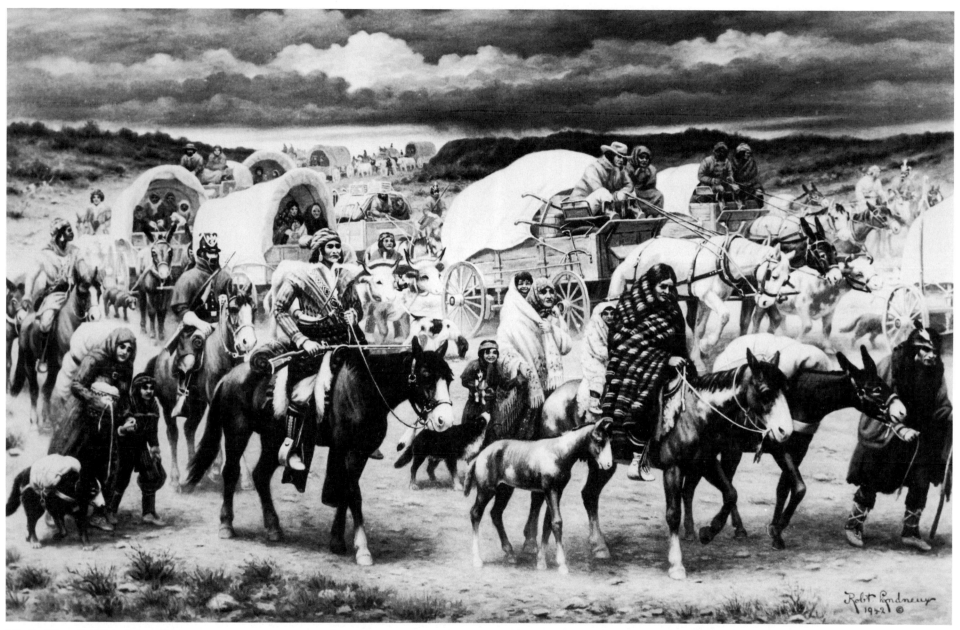

"Trail of Tears," 1942, by Robert Lindneux.
Courtesy of the Woolaroc Museum, Bartlesville, Oklahoma

15

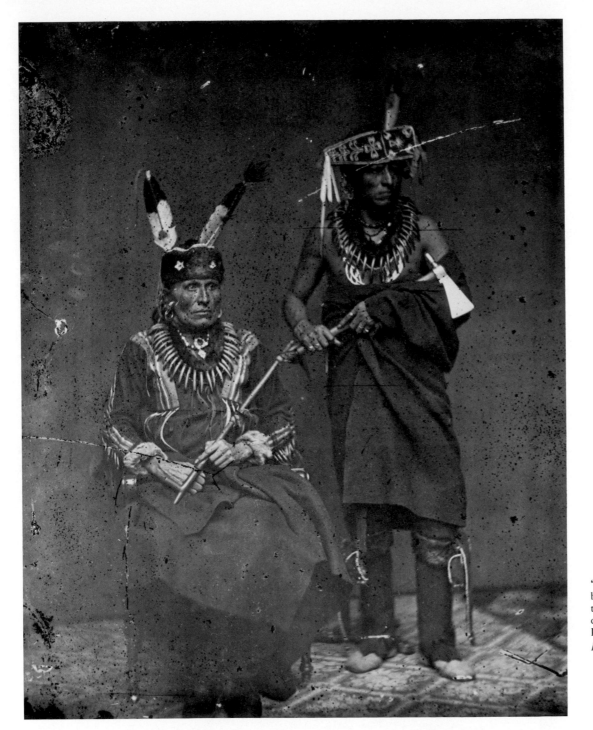

"Man and Chief and the Chief Whom They Look Upon," 1858, by Mathew Brady. Throughout the 1800s federal officials brought tribal representatives to Washington, DC. When these Pawnee chiefs came to the city in 1858, they sat for Mathew Brady at his studio on Pennsylvania Avenue.

RG 111, Records of the Office of the Chief Signal Officer (111-B-5865)

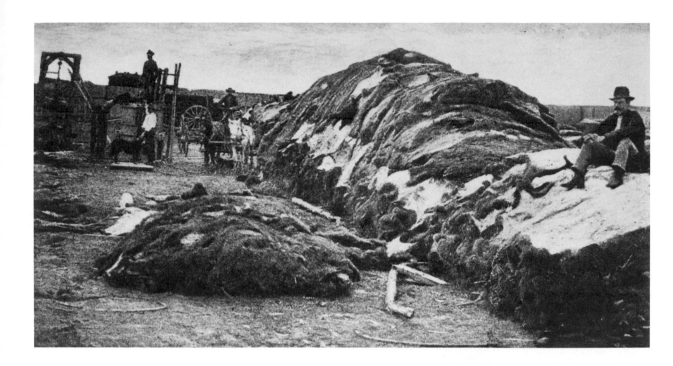

"**Rath & Wright's buffalo hide yard in 1878, showing 40,000 buffalo hides, Dodge City, Kansas,**" by an unknown photographer. Estimates indicate that in the 1870s over a million buffalo a year were killed by white hunters and settlers. Such slaughter created hardships for tribes who lived on the Great Plains and depended on the buffalo for food, clothing, and shelter.

RG 79, Records of the National Park Service (79-M-1B-3)

Body of Ralph Morrison, hunter, late 1880s, by William Soule. Competition for resources raised the level of violence between whites and Native Americans in the West.

Courtesy of the National Anthropological Archives, Smithsonian Institution (negative #2860-W)

17

WARS FOR THE WEST

THE WARS between the United States and Native Americans were numerous and violent. Between 1865 and 1890 the U.S. Army conducted 100 campaigns and at least 1,000 smaller actions against various tribes, using the entire West as the battleground. Led by able leaders such as Sitting Bull, Geronimo, and Crazy Horse, many tribes scored impressive victories over federal troops, but they were eventually overwhelmed by technology and the relentless pressure of white settlement. As each struggle ended, the government confined defeated tribes to "reservations," land where they would be segregated from whites and where they could be educated in Anglo-American customs and technology.

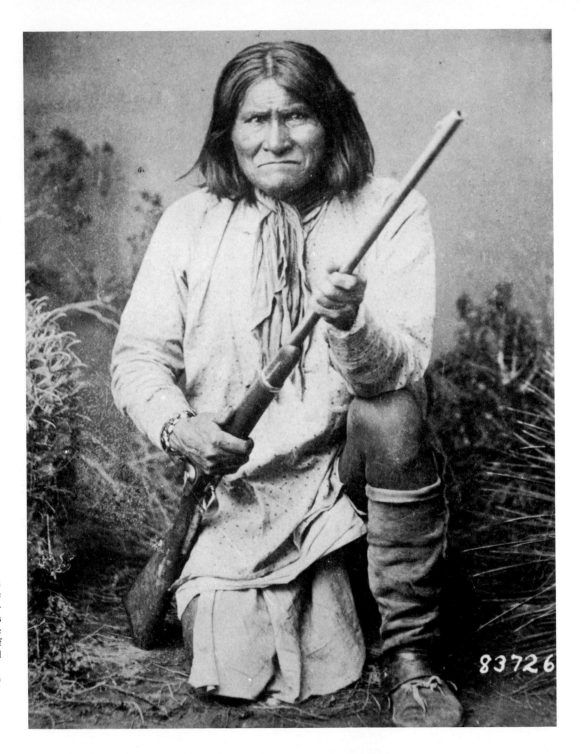

"Geronimo, a Chiricahua Apache; full-length kneeling, with rifle," 1887, by Ben Wittick. When the U.S. government forced the Chiricahua Apache to move from their traditional lands in southeastern Arizona, Geronimo led a band of Chiricahua against soldiers and settlers in Arizona. A master strategist and guerrilla fighter, he eluded capture for 25 years. Once captured, Geronimo and the rest of the Chiricahua were imprisoned first in St. Augustine, Florida, and later near Mobile, Alabama.

RG 111, Records of the Office of the Chief Signal Officer (111-SC-83726)

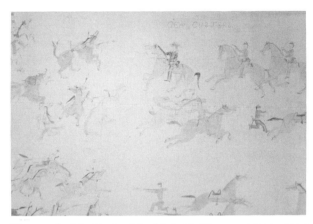

Pictograph of the Battle of the Little Big Horn, ca. 1885, by Chief His Horse Looking (detail). The most famous Native American victory in the wars for the West was the Battle of the Little Big Horn in Montana. There, Sioux, Cheyenne, and Arapaho warriors defeated Gen. George Custer, killing him and his entire detachment of 7th Cavalry troopers on June 25, 1876.

Courtesy of the South Dakota Historical Society, Pierre (accession 74.2.121)

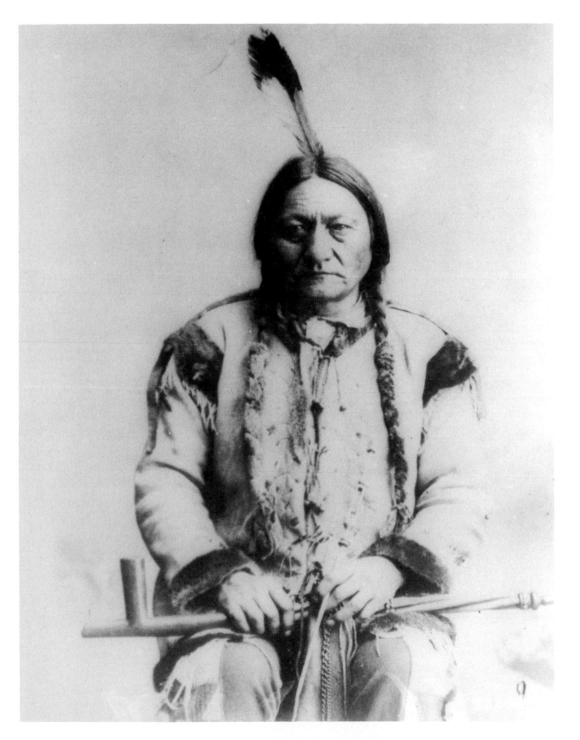

"Sitting Bull. Hunkpapa Sioux," ca. 1885, by David F. Barry. Many Sioux made peace with the U.S. government by the Treaty of Fort Laramie in 1868, but others, including the influential medicine man Sitting Bull, rejected reservation life. When the discovery of gold in 1874 brought prospectors into the Black Hills of Dakota, a sacred place for the Sioux, white-Indian conflict erupted. After the government failed to purchase the land, it ordered military action against the resisting Indians. Sitting Bull, Rain in the Face, and other Sioux warriors created a powerful alliance among several tribes that greatly aided the Native American victory at the Little Big Horn.

RG 111, Records of the Office of the Chief Signal Officer (111-SC-82600)

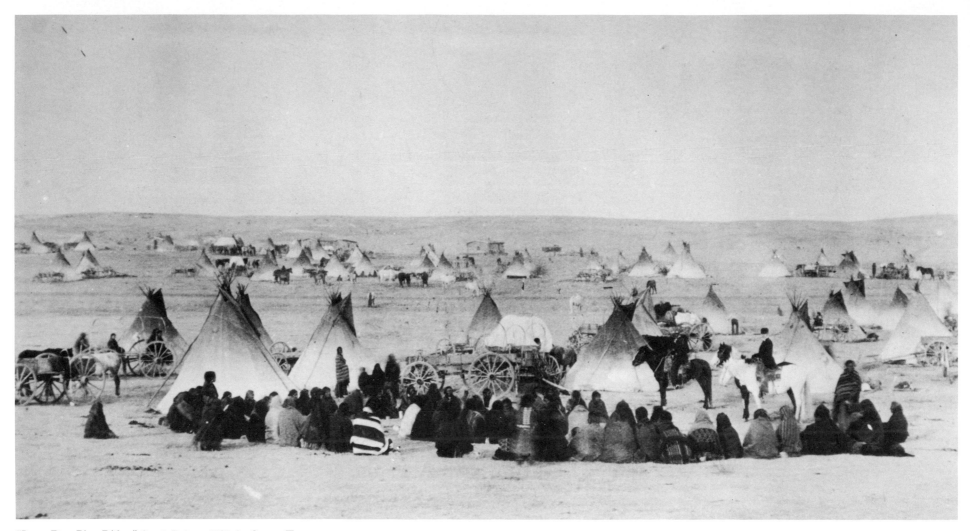

"Issue Day, Pine Ridge," South Dakota, 1890, by George Trager. Confined to reservations and facing a dwindling supply of buffalo, Plains tribes could no longer rely on hunting for food. The government issued food rations as a stopgap measure, until tribes could become "self-sufficient farmers." But the irregular food shipments undermined traditional self-reliance and were subject to corruption at the hand of unscrupulous agents. Few tribes embraced farming; starvation was common.

RG 111, Records of the Office of the Chief Signal Officer (111-SC-82522)

Opposite: **Arapaho Ghost Dancers,** ca. 1890, by Jack Mooney. Ghost Dancing was the most visible sign of a native religious revival that swept through many tribes in the Mountain West and Northern Plains from 1889 to 1891. Led by the Paiute prophet Wovoka, participants believed dancing would raise the dead, bring back the buffalo, reestablish traditional tribal life, and make whites disappear. As larger numbers of Native Americans embraced the practice, whites reacted with fear and misunderstanding and issued decrees prohibiting Ghost Dancing.

Courtesy of the National Anthropological Archives, Smithsonian Institution (negative #55298)

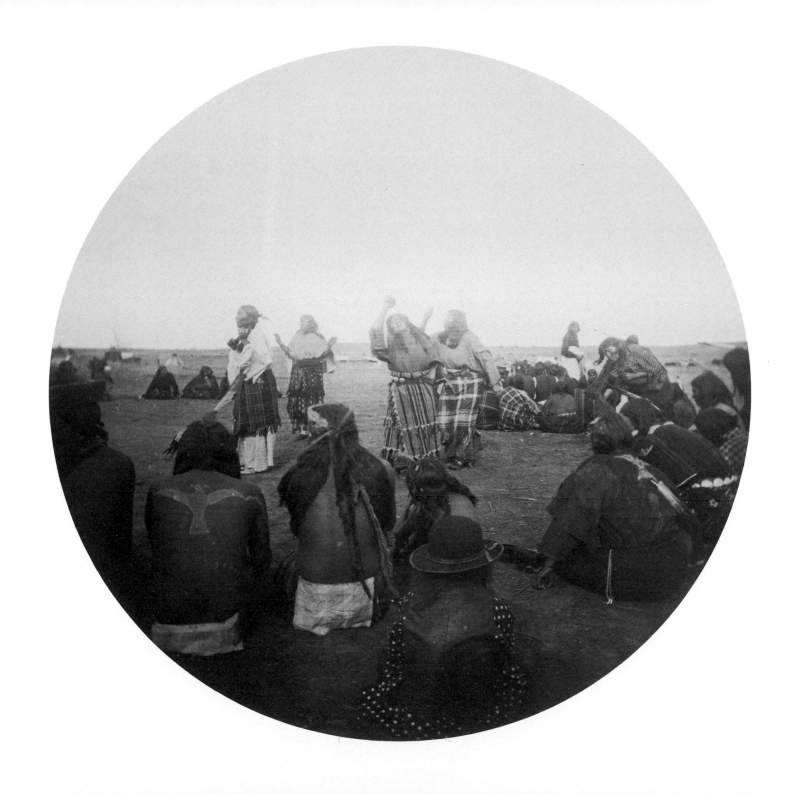

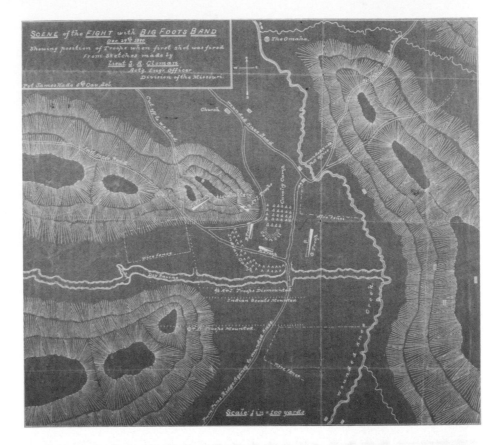

"Scene of the fight with Big Foot's Band, December 29, 1890 Showing the positions of Troops when first shot was fired," from sketches made by Lt. S. A. Cloman. Despite official prohibition, Ghost Dancing at the Pine Ridge Agency in South Dakota became particularly intense. The frightened Indian agents requested troops, whose arrival only inflamed the situation. A small band of Miniconjou Sioux returning to the agency were intercepted by troops from the 7th Cavalry. Cold and hungry, they were surrounded and ordered to camp for the night near Wounded Knee Creek. The next morning as the troops searched for weapons, a gun discharged and fighting broke out. Soldiers raked the camp with gunfire.

RG 165, Records of War Department General and Special Staffs (165-WHC-110)

"Big Foot, leader of the Miniconjou Sioux, lies dead in the snow. Wounded Knee, South Dakota," January 1891, by George Trager. When the "battle" at Wounded Knee ended, 153 Sioux, many of them women and children, were dead and 50 were wounded; 25 soldiers were killed and 39 were wounded. Items of ceremonial clothing and other objects were removed from the bodies by soldiers and later sold at auction.

RG 111, Records of the Office of the Chief Signal Officer (111-SC-82412)

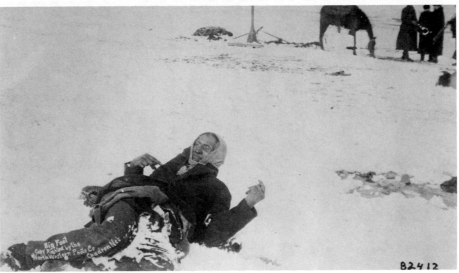

PRESSURES TO ASSIMILATE

THE END OF organized armed resistance brought huge change for Native Americans. On reservations, federal Indian agents as well as private charities attacked the old ways and forced Native Americans to adopt white ways. They targeted everything traditional: dress, language, religion, dances, games, economy, even burial practices. They hoped to force tribes to accept institutions such as Christianity and private property and adopt livelihoods such as farming. They also created a system of boarding schools to educate young Indian boys and girls by removing them from the influence of their elders and subjecting them to curriculum designed to eradicate their native cultures.

Blackfeet farmers, Flathead Irrigation project, Montana, 1909, probably by Walter J. Lubken. For white reformers interested in "improving" the lives of Native Americans, encouraging farming and private property were key goals. Photographs like this one were designed to show the progress individuals were making toward becoming self-reliant farmers. In reality, few tribes willingly embraced either goal. In 1887, 138 million acres were owned by Native Americans. By 1938, about two-thirds, including most of the best lands, had passed into white hands.

RG 75, Records of the Bureau of Indian Affairs, Flathead Irrigation project, photograph #221, National Archives–Pacific Northwest Region

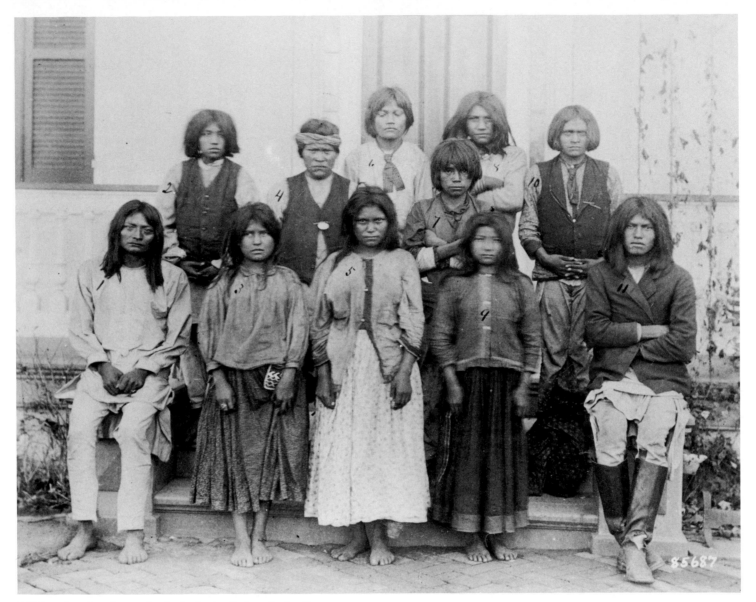

"Chiracahua Apaches as they looked upon their arrival at the Carlisle Indian School, Pennsylvania," 1886, probably by John N. Choate. Army officer Richard Henry Pratt opened the Carlisle Indian School, a boarding school for Native Americans, in 1879. The school was the first of many dedicated to educating Native Americans. Its motto was: "To civilize the Indian, get him into civilization. To keep him civilized, let him stay." Headmaster Pratt used these "before and after" photographs in lectures to prove that Native Americans could be induced to abandon their traditional ways.

RG 111, Records of the Office of the Chief Signal Officer (111-SC-85687)

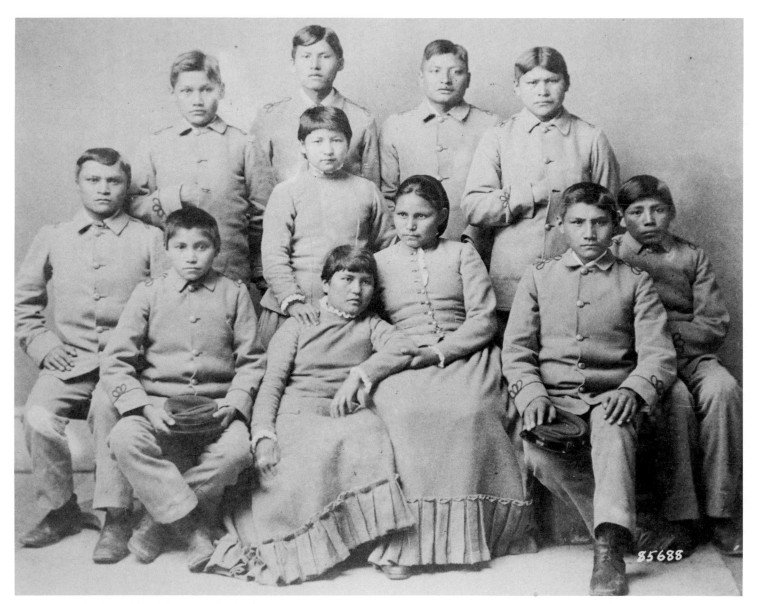

"Chiracahua Apache Indians after four months training at Carlisle Indian School, Carlisle, Pennsylvania," 1886, probably by John N. Choate. After arriving, students had their hair cut and were given uniforms and new names. Discipline was strict. Students were forbidden to speak their native languages or practice tribal religions. Their education consisted of basic reading and writing, along with training in domestic skills for girls and manual trades for boys.

RG 111, Records of the Office of the Chief Signal Officer (111-SC-85688)

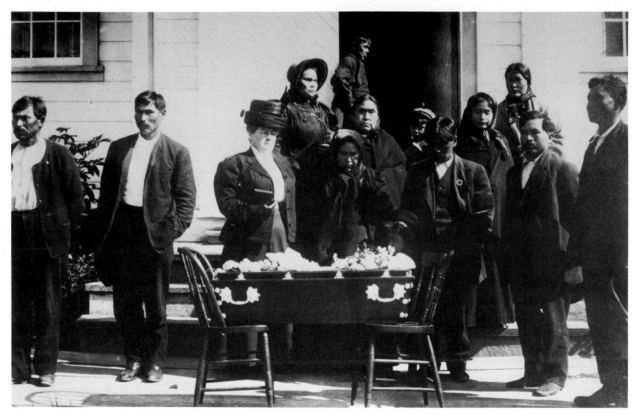

"Funeral for a child, Metlakahtla, Alaska," ca. 1900, probably by
B. A. or H. Haldane.
*National Archives Donated Materials, Henry S. Wellcome Collection,
National Archives–Alaska Region*

**T. J. Morgan, Commissioner of Indian Affairs, to C. A.
Bartholomew, Indian agent, Ute Agency,** January 9, 1891. Even
death brought no relief from the pressure to assimilate.
*RG 75, Records of the Bureau of Indian Affairs, Consolidated Ute, file 070,
National Archives–Rocky Mountain Region*

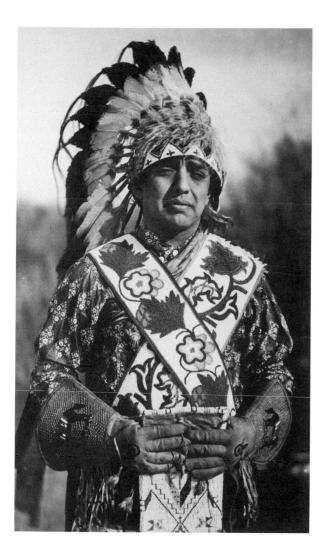

SURVIVAL AND RENEWAL

DURING THE 19TH CENTURY, many whites believed that American Indians were destined for extinction. But Native Americans stubbornly refused to move into this bleak future. Their numbers began to increase, rising from a low point of only 250,000 in 1900 to 1.5 million in 1980. Accompanying this demographic growth was a cultural renewal that sparked a resurgence in Native American arts, customs, crafts, and religions as well as stronger tribal governments and economic institutions.

Today Native Americans in the West confront a multitude of problems: poverty, inadequate health care, alcoholism, and poor educational opportunities, in addition to the continuing dilemma of retaining unique tribal identities while living in the midst of a larger non-native society. Despite these burdens, their survival and achievements, against all odds, have been truly heroic.

"George P. La Vatta in regalia," ca. 1940, by an unknown photographer.
RG 75, Records of the Bureau of Indian Affairs, Portland Area Office, Tribal Operations Branch, National Archives–Pacific Northwest Region

"George P. La Vatta, Guidance and Placement Officer and Miss Marguerite Varner, Yakima Indian, stenographer," ca. 1940, by an unknown photographer. Educated at the Carlisle Industrial School for Indians, Shoshone George P. La Vatta spent his career working for the Bureau of Indian Affairs as a placement officer, organizational field agent, Superintendent of the Taholah Indian Agency in Washington State, and head of the Tribal Operations Branch in Portland, Oregon. He was also a founding member of the National Congress of American Indians, a Native American civil rights organization.

RG 75, Records of the Bureau of Indian Affairs, Portland Area Office, Tribal Operations Branch, National Archives–Pacific Northwest Region

"Navajo Tribal Council," Window Rock, Arizona, January 12–13, 1942, by Milton Snow. The first Navajo Tribal Council, the legislative body of the Navajo Nation, was elected in 1923. Representatives are selected from 74 tribal council districts.

RG 75, Records of the Bureau of Indian Affairs (75-NG-NO-11-337)

"Indian Spearing Fish at Celilo Falls, Columbia River," Oregon, ca. 1940, by an unknown photographer.

RG 75, Records of the Bureau of Indian Affairs (75-N-YAK-126)

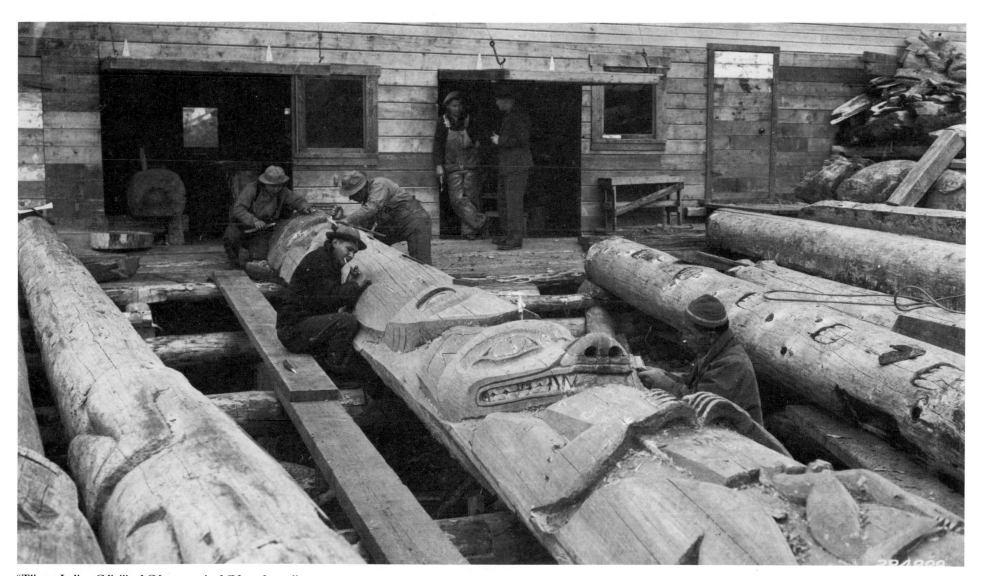

"Tlinget Indian C.[ivilian] C.[onservation] C.[orps] enrollees
working under the supervision of Indian craftsmen, to restore
the Ebbets pole at the Saxman Indian village workshop in the
Tongass National Forest," Alaska, May 16, 1939, by C. M.
Archbold. During the "Indian New Deal" of the 1930s, government
programs were aimed at encouraging native artisans.

RG 95, Records of the U.S. Forest Service (95-G-384899)

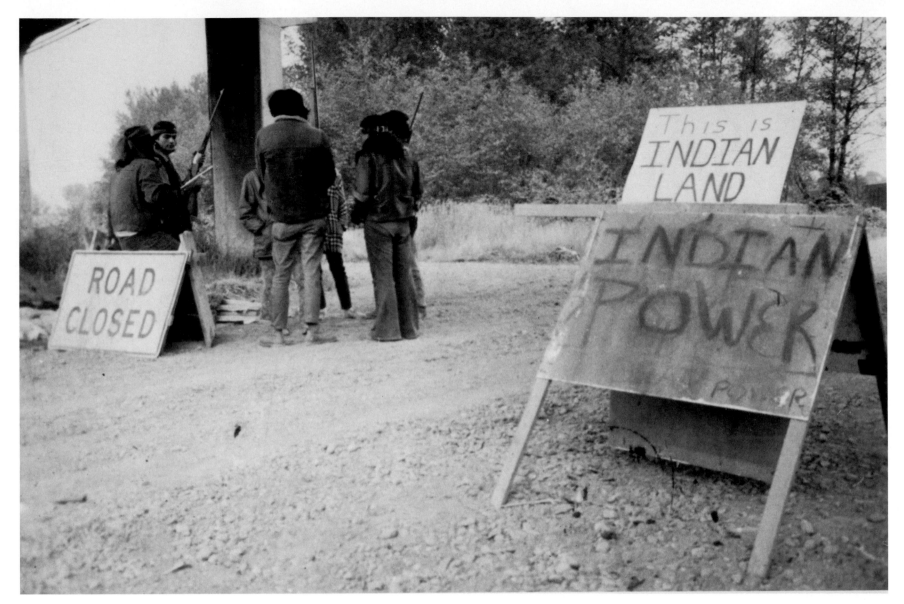

"American Indian protest, near Seattle, Washington, 1971," by Michael D. Sullivan. During the 1960s and 1970s, Native Americans joined in the political activism inspired by the African-American civil rights movement. This protest was over violations of tribal fishing rights along the Columbia River.

RG 362, Records of Agencies for Voluntary Action (362-VS-4D-29A)
© Michael D. Sullivan

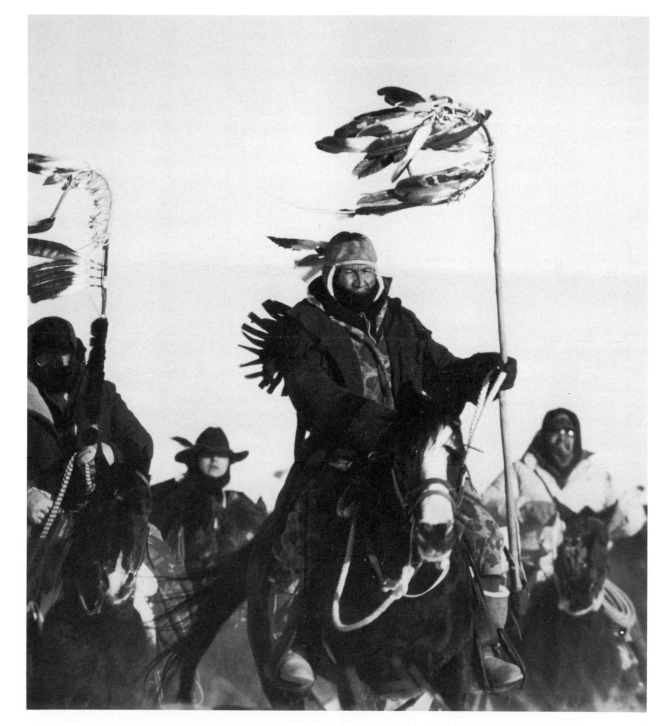

"100th Anniversary Ride," Wounded Knee, South Dakota, December 29, 1990, by Allen Russell. One hundred years after the killings, over 300 riders took part in the Big Foot Memorial Ride, which retraced the 1890 ride to Wounded Knee. Shortly after the massacre, Lakota medicine man Black Elk said that Wounded Knee had broken the sacred hoop of the world, destroying life's unity. But he also prophesied that after seven generations the Lakota would experience a cultural renewal and that the hoop would be mended. The 100th anniversary of Wounded Knee coincided with the 7th generation of Lakota.

© *Allen Russell/Profiles West*

◆
The West as Home
RENDEZVOUS

"In my little restaurant at Monterey, we have sat down to table, day after day, a Frenchman, two Portuguese, an Italian, a Mexican, and a Scotsman: we had for common visitors an American from Illinois, a nearly pure blood Indian woman, and a naturalized Chinese; and from time to time a Switzer and a German came down from country ranches for the night."

Robert Louis Stevenson
in California, 1879–80

FEW PLACES ON EARTH can boast that they are a meeting ground for such a variety of people as the American West. Originally home for numerous Native American cultures, the West also drew settlers from around the globe. Some of these immigrants came directly from Europe, others pushed across the Plains from the Eastern United States. But people moved into the region from all directions: Mexicans from across the Rio Grande; Russians from the north; formerly enslaved blacks from the American South; Chinese, Japanese, and Vietnamese from across the Pacific Ocean.

This cosmopolitanism has caused one historian to compare Western history to the great fur "rendezvous" of the 1820s and 1830s, during which trappers, explorers, mountain men, Native Americans, Spaniards, and French Canadians came together annually to trade goods, socialize, exchange news, and sometimes fight. Accordingly, the American West is a place where cultures and people meet, compete, negotiate, and clash.

"Eighteen miles from Stanton. 'Board and lodging' en route for Stanton," Fort Stanton, New Mexico, date unknown, by A. J. Buck. *RG 90, Records of the Public Health Service (90-G-94-1)*

GETTING THERE

WHETHER they crossed the continent by wagon or the Pacific by boat, for most the trip to the West was a difficult one. Beyond the physical discomforts of travel, settlers still faced the sorrow of leaving family, the trials of adjusting to a new physical environment, and the shock of coping with different cultures. Many arrived, took a job, earned some money, and returned to their old homes; others stayed to make a new life.

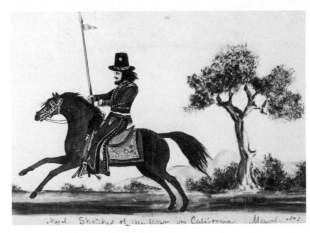

"Californian Lancer," 1846–47, by William H. Meyers, from *Naval Sketches of the War in California*. When the United States emerged victorious from the 1846–47 war with Mexico, it acquired not only much of the American Southwest but also a large Hispanic population in what is now Arizona, California, and New Mexico.

Franklin D. Roosevelt Library, National Archives and Records Administration

Chinese men at work on Central Pacific Railroad, Sierra Nevada, 1877, by C. E. Watkins. Building the transcontinental railroad was one of the most spectacular engineering feats of the 19th century. It took 20,000 workers 6 years to lay the 1,700 miles of track between Omaha and Sacramento. Most of the workers who built the Central Pacific Railroad, which ran east from California, were Chinese immigrants. Most of those who built the Union Pacific, which ran west from Nebraska, were immigrants from Ireland, Germany, or Czechoslovakia.

Courtesy of the Denver Public Library, Western History Department (negative #F 30128)

34

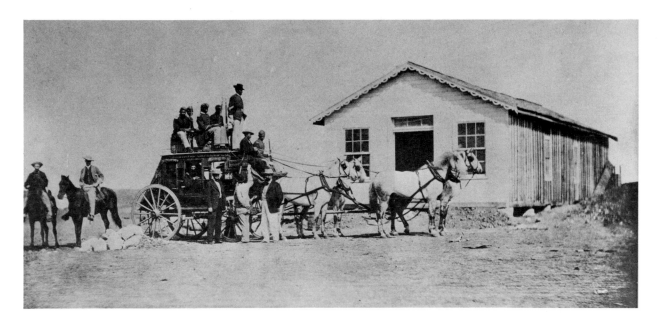

Typical stagecoach of the Concord type used by express companies on the overland trail. Soldiers guard from atop. Location unknown, ca. 1869, by an unknown photographer. The U.S. Army played a crucial role in developing the West. The "frontiersmen in blue" surveyed roads, manned farflung systems of forts, and protected stagecoaches and settlers. Among the units stationed in the West were two cavalry regiments of African Americans. Native Americans called these troopers "Buffalo Soldiers" because of the texture of their hair and because the soldiers' courage and fighting spirit recalled that of the buffalo.

RG 111, Records of the Office of the Chief Signal Officer (111-SC-87712)

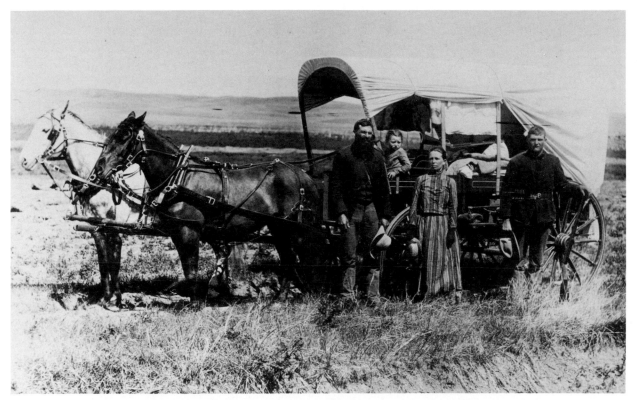

"Covered Wagon of the great western migration, 1886 in Loup Valley, Nebraska, a family poses with the wagon in which they lived and traveled daily during their pursuit of a homestead," by an unknown photographer. The Homestead Act of 1862 allowed any citizen or prospective citizen over 21 years old to claim 160 acres of public land provided he or she paid a small filing fee, improved the land, and resided there for 5 years. In theory, the availability of cheap land was supposed to encourage small farmers to settle in the West. In practice, speculators bought much of the land.

RG 69, Records of the Work Projects Administration (69-N-13606)

60,000 ACRES

af första klassens

ÅKERBRUKSLAND,

allt under BEVATTNING genom kanaler

—— från ——

BIG LARAMIE RIVER.

THE WYOMING DEVELOPMENT COMPANY'S LAND är beläget i Laramie County, Wyoming Territory, omkring 60 mil west om Cheyenne, Territoriets hufvudstad, vid stambanan af Union Pacific Jernvägen samt vid Cheyenne and Northern Jernvägen, hvilken löper genom landet till en station vid Wheatland, som är Kompaniets stad.

Detta land har af ointresserade och sakkunniga domare förklarats vara bland den yppersta odlingsmark i vestern. Jordmånen är djup, och vexlar i natur från lera till grus. En stor del utgöres af en rik sandblandad lera, väl belägen för vattning. Det har en obetydlig, gradvis sluttning, så att grunden icke spolas bort under påsläppandet af vattnet.

Alla små sädesslag kunna odlas med fördel, gräs likaså — alfalfa ger två skördar om året, med i medeltal halfannan till två ton för hvarje slåtter, eller tre till fyra ton på acren om året.

Frukter likaså. Som ett bevis på landets naturliga fruktbarhet togs ett medelprof af hvete, vuxet derstädes under innevarande års sommar och förevisades i täflan med hvete från olika platser i Colorado och Nebraska, vid Wyoming Fair Associations årliga utställning i Cheyenne förliden September och tillerkändes första priset. Inga gödningsämnen af något slag hade användts på jorden.

Årstiderna för odling och skörd äro långa och tillåta alltså sådden att nå full mogenhet.

Landet är icke utsatt för stora snöfall och vintrarna äro i medeltal hvarken stränga eller långvariga.

Wyomings helsosamma klimat kan icke öfverträffas, och atmosferen är alldeles fri från den fuktighet som förnimmes i de Östra Staterna. Om

Fahr., och nätterna äro svala

...elar. Vatten i behöflig myc-
...på just den tid, det erfordras,
...flödet kan regleras till hvarje
...kena, helt och hållet eller del-
...et. Landets naturliga frukt-
...lika skördar. Jordmånen ut-
...evattnad, iständ att bära alla
...ky Mountains-regionen, utan
...lvete, Hafre, Korn, Råg, alla
...ver m. fl. Alfalfa, (som lem-
...or mångfald af grönsaker och
...d afkastning.

...Förenade Staterna högst i Co-
...ttio bushel på acren kan man
...r acre. I tillägg till produce-
...nder detta land förträfflig läg-
...l af alla slag, vare sig rasdjur
...ir betäckt med naturligt gräs
...många månader om året kun-
...någon annan kostnad än till-
...a m. fl. rikligt förse dem med
...n ofvan omnämnts, äro odug-
...en och oåtkomliga för bevatt-
...till betesmark endast. Mejeri-
...tgifvande. Omkostnaden för
...iteter utmärkt mjölk och pro-
...smör, som f. n. säljes i Terri-
...ernväg. Der är likaså en sta-
...för afvel.

...ngar hänvände sig för cirkulär och kartor antingen till

THE WYOMING DEVELOPMENT CO.,

CHEYENNE, WYOMING Terr.

eller

The American Emigrant Company,

R. E. JEANSON, Agent,

P. O. Box 1040. No. 30 STATE STREET, NEW YORK.

"60,000 Acres af första klassens Åkerbruksland, allt under Bevattning genom kanaler från Big Laramie River" ["60,000 acres of first-class farmland for cultivation, all irrigated by canals from the Big Laramie River"], from *Svensk Almanack for Skottaret 1888.* Potential farmers from around the globe were enticed to emigrate by announcements like this one from the Wyoming Development Company, which promised "among the best arable land in the West" and a "climate entirely free of dampness."

RG 134, Records of the Interstate Commerce Commission

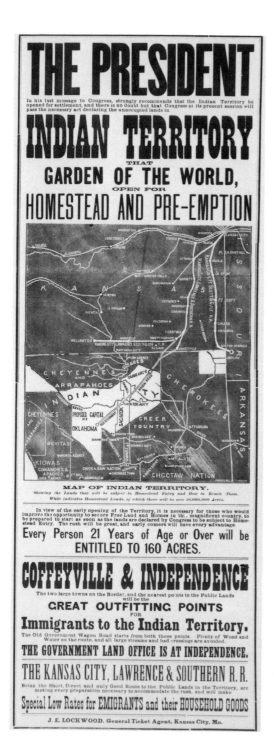

"Indian Territory, That Garden of the World Open for Homestead and Pre-emption," ca. 1880. As early as 1817, the federal government attempted to create a separate "Indian Territory" in the West. As more people came west, the federal government faced increasing pressure to renege on their treaty agreements and open these lands to white settlement. By 1876 Indian Territory had shrunk to what today constitutes most of the state of Oklahoma.

RG 393, Records of the U.S. Army Continental Commands, 1821–1920, Department of Missouri, Letters received, 1880

"Drawing for Kiowa, Comanche, Apache, and Wichita Indian lands, Okla., 10:00 A.M. The tops of freight cars furnished seats for some 30,000 persons who witnessed this drawing." July 29, 1901, by an unknown photographer. Indian Territory was opened to settlers through lottery drawings that awarded individuals the right to homestead. Other unoccupied lands were opened by "runs," in which up to 60,000 settlers rushed at once onto the land on the day it was opened, staked their claims, and held down their lots.

RG 49, Records of the Bureau of Land Management (49-WLM-2-34)

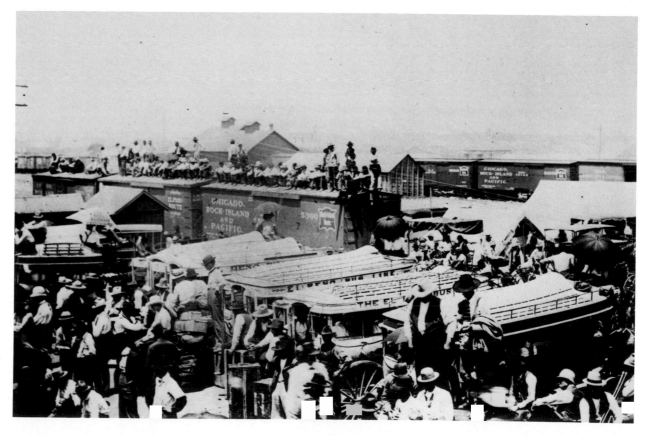

Custom House Business Astoria Oregon, July 28-1891

Descriptive list of Chinese Merchant furnished to the
following Chinese Merchant, Departing temporarilly from the
United States, to be presented to the Customs Officers on his
return to the United States.

Discription

Name-Go Chow, Age-28 Years, Occupation-Merchant, of the firm of
Tai wo Long & Co doing business at No 557- 3 d Street Astoria
Oregon, Height 5 feet 2 & 1/2 Inches Complexion-Dark, Eyes-Dark
Physical Marks-One Small Scar on Right Temple, One Small Scar
on Left Eyebrow,

 This is to certify that the above described
Chinese Merchant presented himself before me at Astoria Oregon
before departing from the United States, and is given as Prima
Facie evedence of his right to return, Photograph hereto
attached is a true likeness at time of departure
Given under my hand and Seal the date above written

 Notary Public for State of Oregn

We the undersigned, hereby certify
that we know the above described
Go Chow, and that he is a Chinese
Merchant doing business as
ab ove described

"Certificate of Identity for Go Chow," Astoria, Oregon, 1891. In an effort to restrict Chinese immigration into the United States, Congress enacted Chinese Exclusion Acts in 1882, 1892, and 1902. Designed to prevent Chinese immigrants from competing for jobs with white workers, the acts exempted Chinese merchants, students, and visitors from restrictions. This certificate of identity allowed merchant Go Chow to leave and reenter the United States.

RG 85, Records of the Immigration and Naturalization Service, National Archives–Pacific Northwest Region

Opposite: **"Examining passengers aboard ships, vessel is the Shimyo Maru,"** Angel Island, California, 1931, by an unknown photographer. For millions of Asian immigrants, Angel Island, near San Francisco, was the initial point of entry into the United States.

RG 90, Records of the Public Health Service (90-G-152-2040)

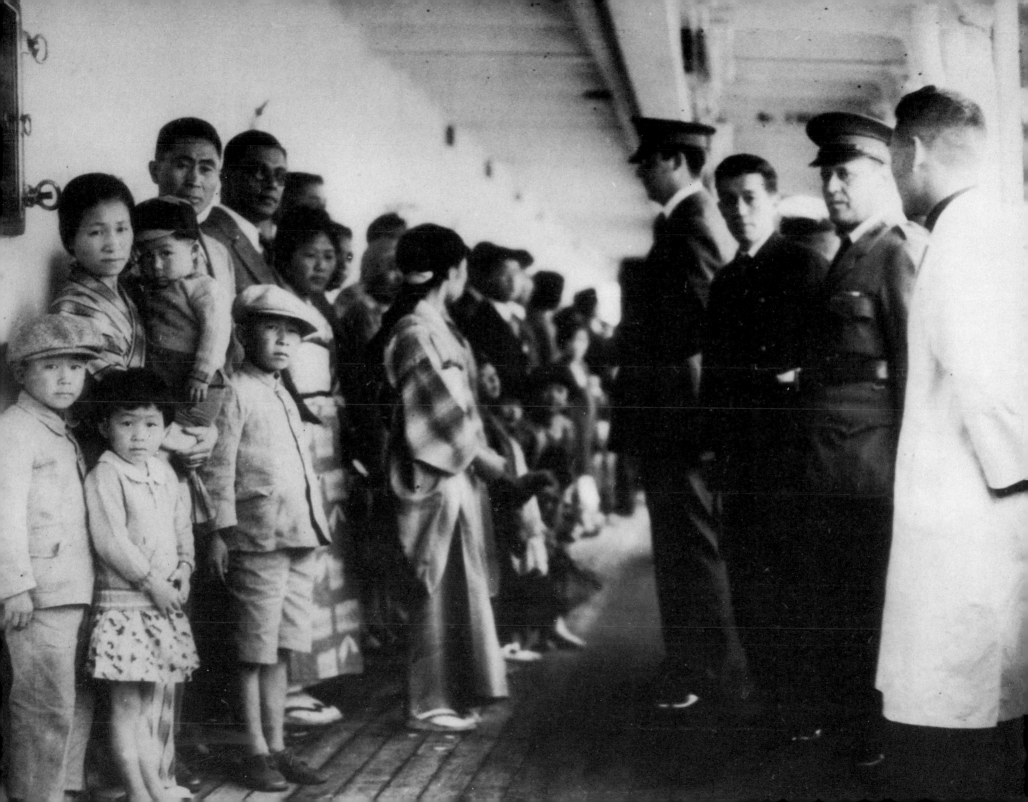

"Migratory white cotton pickers stopped by engine trouble alongside the road. Related family groups frequently travel like this, in pairs or in caravans of three or four." Eloy, Arizona, November 1940, by Dorothea Lange. Fleeing the economic hardship of the Great Depression and the Dust Bowl, migrants from the Southern Plains crossed the Southwest in search of work.

RG 83, Records of the Bureau of Agricultural Economics (83-G-44211)

"A Mexican family leaves to help out with the harvest across the border," 1944, by an unknown photographer. During World War II hundreds of thousands of "braceros" came to the American West as migrant workers from Mexico, when wartime labor shortages made their importation necessary. Many came through the federal government's "bracero" program, which recruited Mexican nationals to work on U.S. farms and railroads. The program paid transportation and living expenses, usually for a 6-month contract.

RG 16, Records of the Office of the Secretary of Agriculture (16-N-6166)

MAKING A LIFE

MOST PEOPLE CAME to the West seeking new opportunities. Some sought cheap land, a claim on a gold or silver mine, or new markets for their skills. Others were looking for a place to practice their religion without persecution. While these goals were attainable for some, settlers also found a harsh environment, hard work, long hours, and sacrifice. Some fell victim to sickness, violence, or disappointment and died or returned to their old homes. Still, as these images reveal, many others "proved up" and eventually made careers, communities, and families.

Census schedule for Shoshone County, Idaho, 1870. This census schedule shows the diversity of the West's population as early as 1870. That year less than one-half of Idaho's non-Indian population was born in the United States. A close examination of the schedule also demonstrates that, contrary to common belief, the early West was not a masculine preserve.

RG 29, Records of the Bureau of the Census

"A drinking 'bee' at White Chapel, Dawson," Alaska, ca. 1900, by Larss and Duclos. An established part of almost every western boomtown, where men greatly outnumbered women, was the brothel. Prostitutes were usually poor immigrant women who sought ways to supplement the small amounts of money they could earn through more respectable employment.

Courtesy of the Alaska Historical Library, Juneau, Alaska (PCA-41-53)

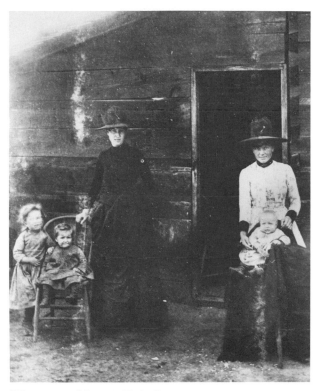

"Mormons at Mormon Dairy," Mormon Lake, Arizona Territory, 1887, by F.A. Ames. Driven across the United States by religious persecution, members of the Church of Jesus Christ of Latter-day Saints (Mormons) founded Salt Lake City, Utah, in 1847. By the 1880s, Mormon settlements had spread throughout the Mountain West.

RG 106, Records of the Smithsonian Institution (106-FAA-40B)

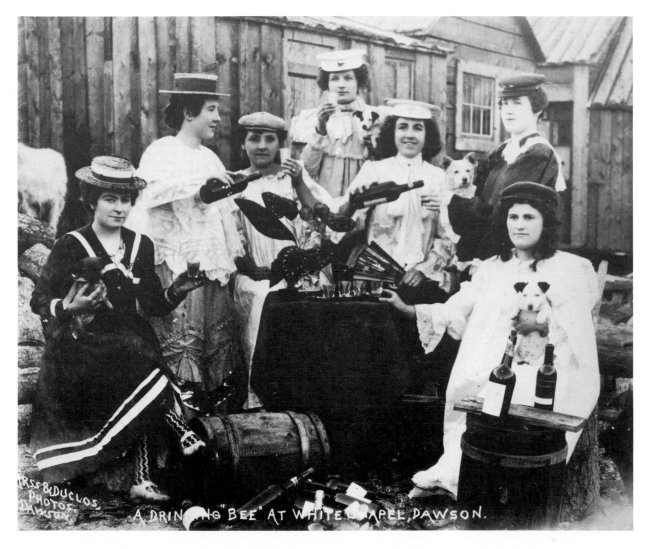

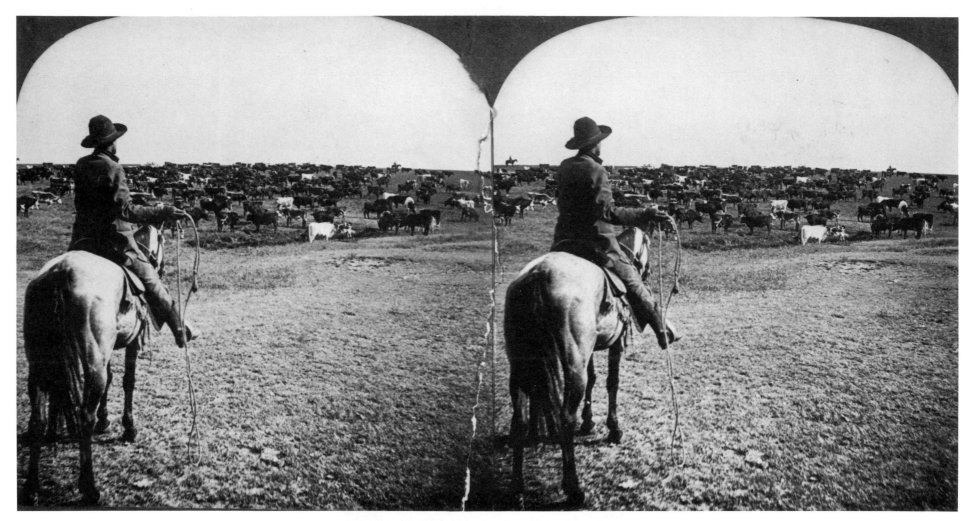

"Roundup on the Sherman Ranch, Genesee, Kansas. Cowboy with lasso readied looks beyond the herd on the open range to his fellow cowpunchers waiting on the horizon," 1902, stereo view by an unknown photographer. Cattle drives were being made by Mexican cowboys as early as the 1540s, but the famous "long drives" of cattle north from Texas to the plains of Colorado and Kansas began after the Civil War as a way of moving herds to more profitable markets.

RG 165, Records of the War Department General and Special Staffs (165-XS-27)

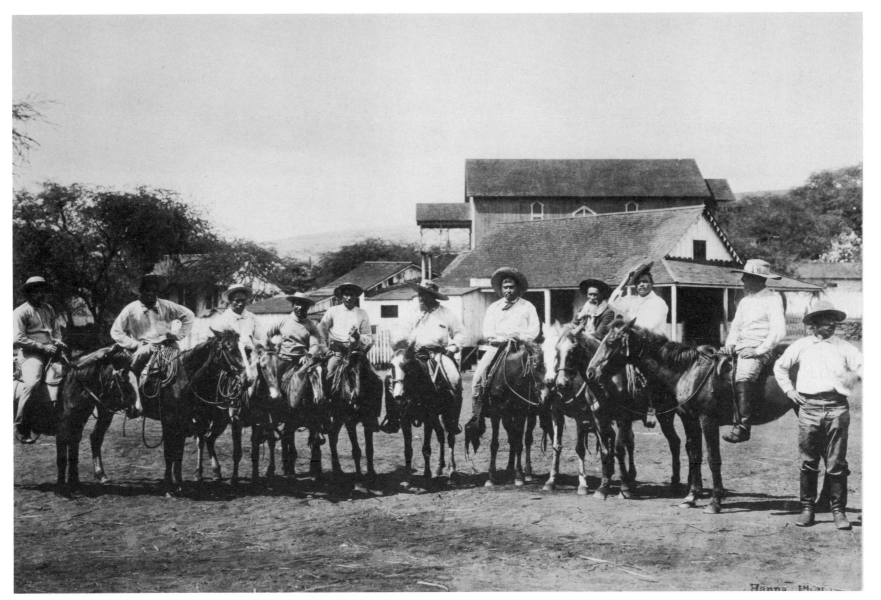

"Hawaiian Cowboys, Waimea," Hawaii, 1899, by H. R. Hanna.
Cattle were introduced to Hawaii in 1793. In 1832, King Kamehameha
III brought three Hispanic "vaqueros" from California to the islands to
train Hawaiians to handle horses and cattle. Hawaiian cowboys, or
"paniolos," were soon riding the range and herding cattle much like
their mainland counterparts.

RG 92, Records of the Office of the Quartermaster General (92-FL-4-4-12)

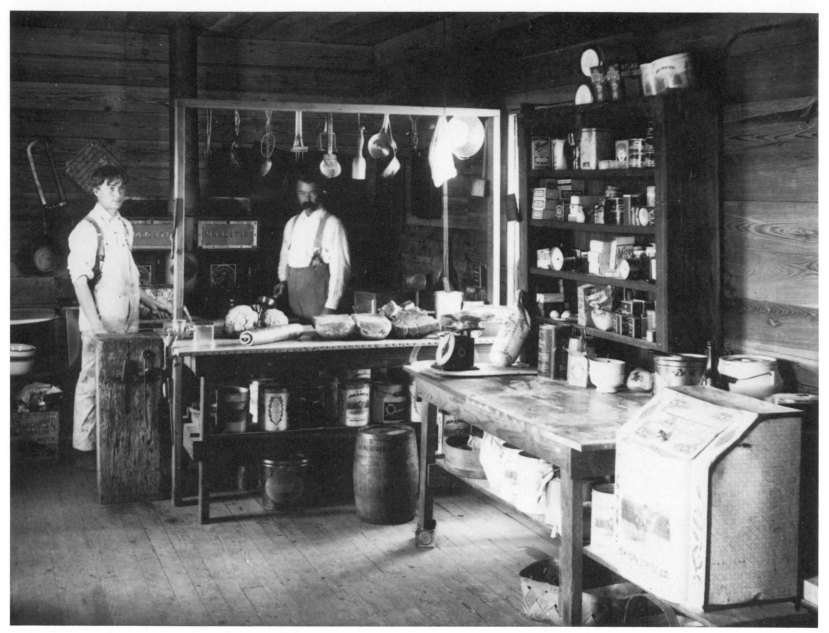

"U.[nited] S.[tates] R.[eclamation] S.[ervice] Kitchen, Mess Hall, Avalon Dam," New Mexico, October 29, 1906, by Walter J. Lubken. Bureau of Reclamation construction projects used hundreds of workers to dam western rivers and build irrigation canals. The crews needed kitchens such as this one.

RG 115, Records of the Bureau of Reclamation (115-JD-119)

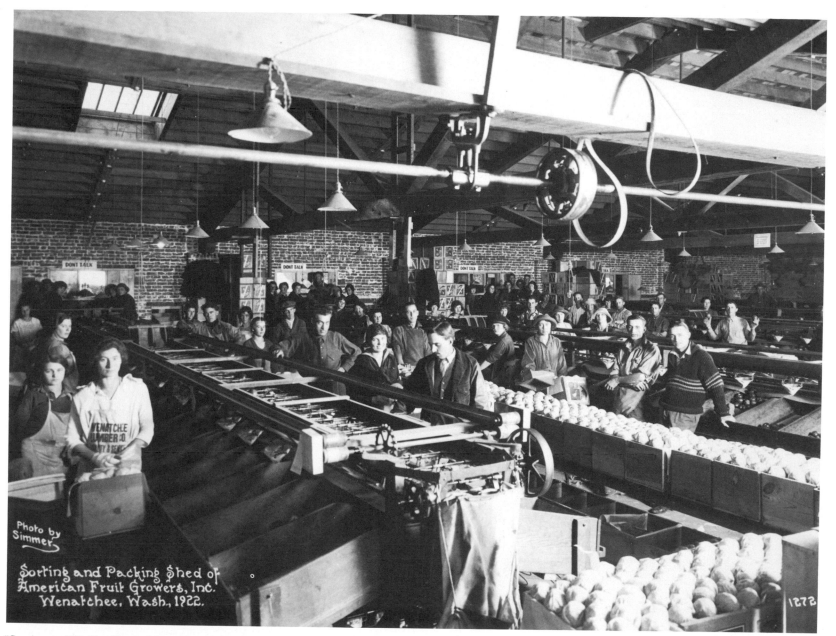

"**Sorting and Packing Shed of American Fruit Growers, Inc. Wenatchee, Wash., 1922,**" by Simmer. By the 1920s the West remained largely agricultural, but even this sector of the economy had been touched by industrial technology and by the influx of women into the work force.

RG 86, Records of the Women's Bureau (86-G-1D-5)

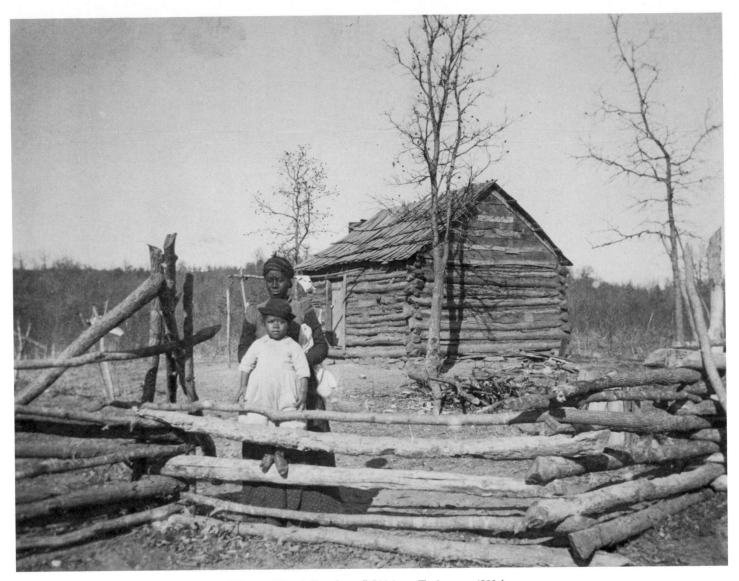

"Home of Creek Freedmen," Oklahoma Territory, ca. 1900, by an unknown photographer. Although slavery existed among several tribes, African Americans escaping slavery in the South were often welcomed into Native American communities. Intermarriage was common.

RG 48, Records of the Office of the Secretary of the Interior (48-RST-5B-2)

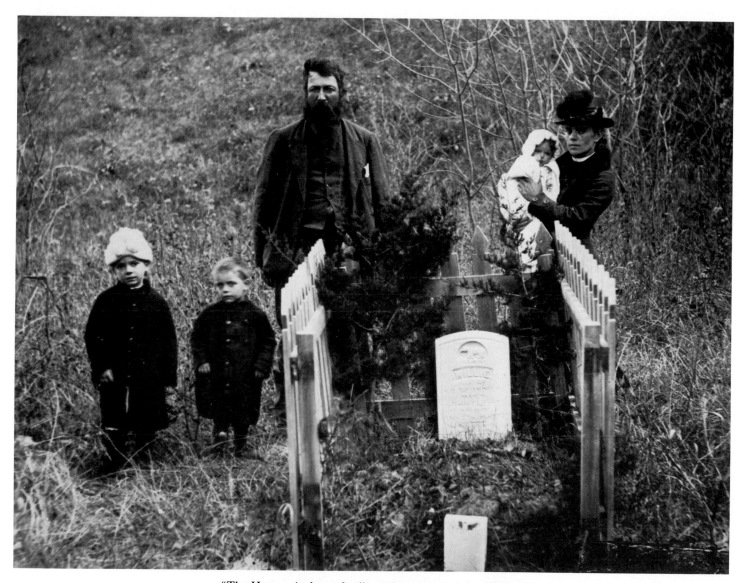

"The Harvey Andrews family at the grave of their child on their own farm near New Helena and Victoria Creek in Cedar Canyon. The cedars in Cedar Canyon made Mr. Andrews a rich man by his selling cedar posts and ridge logs for the settlers sod houses. Standing at graveside left to right, Mary Andrews Aldrich, Charles Henry Andrews, Harvey B. Andrews, Mrs. Jennie Andrews holding daughter Lillian Andrews Downey. Grave is that of 19 month old infant, Willie son of Harvey and Jennie Andrews." Nebraska, 1887, by Solomon D. Butcher.

Courtesy of the Nebraska State Historical Society (B 983-2360a)

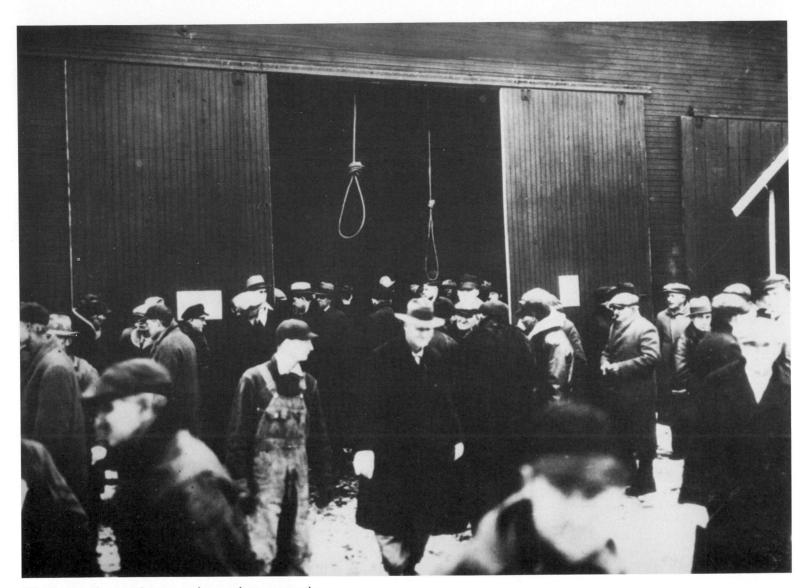

"Two hangman's nooses hang as a grim warning to prospective bidders on this foreclosed farm. In this way many farms sold for only a few cents until the Farm Debt Adjustment Committee came into being." Location unknown, ca. 1937, by an unknown photographer. During the Great Depression the Great Plains were racked with economic misery. When farm families could no longer pay their debts, banks foreclosed. In response, the friends of those losing their homes gave clear signals that new owners would be unwelcome.

RG 16, Records of the Office of the Secretary of Agriculture, General Correspondence, 1937

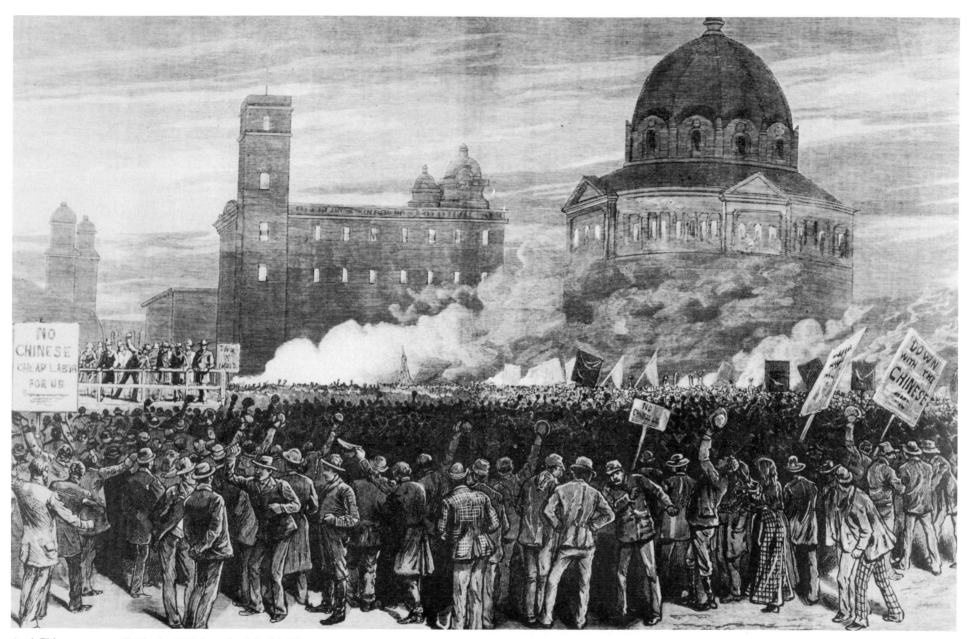

Anti-Chinese protest, California, 1880, from *Frank Leslie's Illustrated News,* March 20, 1880. Facing limited job prospects, white workers found a readily available scapegoat for their anger in Chinese immigrants. In the 1870s and 1880s, anti-Chinese riots broke out in several western cities.

Courtesy of the Denver Public Library, Western History Department

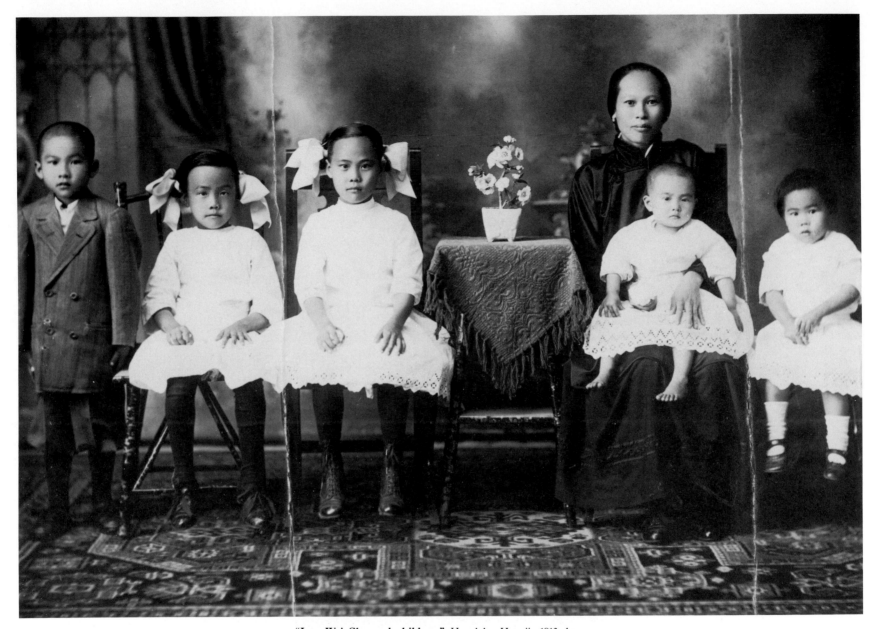

"Lee Wai She and children," Honolulu, Hawaii, 1913, by an unknown photographer. Lee Wai She submitted this photograph as partial evidence in her successful effort to prove the Hawaiian birth of her children in order to establish their right to remain in the United States under the Chinese Exclusion Acts.

RG 85, Records of the Immigration and Naturalization Service, National Archives–Pacific Sierra Region

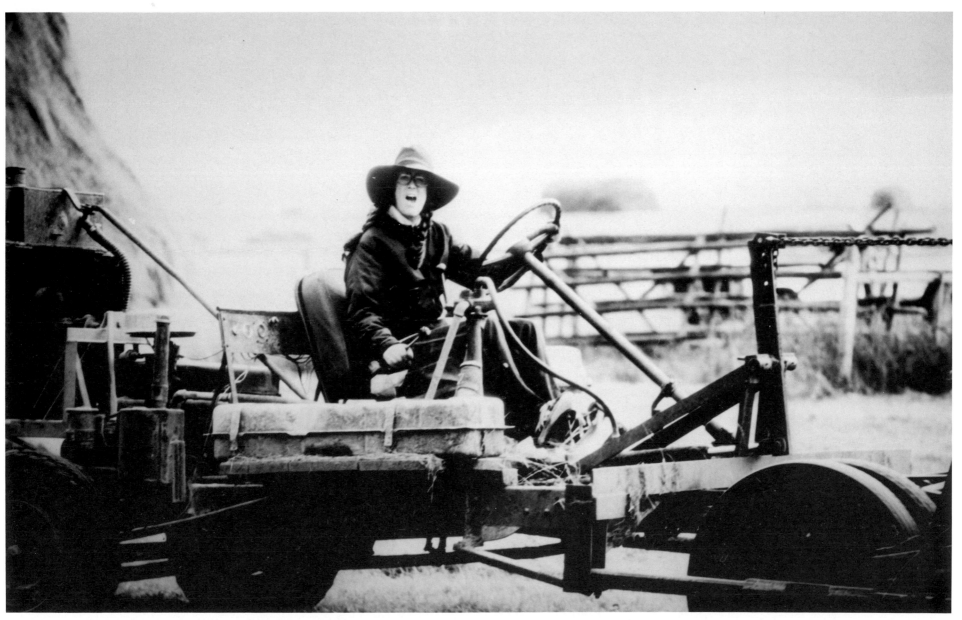

"Rancher. Buck Rack. Montana," 1980, by George Wuerthner.
© *George Wuerthner*

Surveying the West
"STUPENDOUS AND REMARKABLE MANIFESTATIONS"

"The impression then made upon me by the stupendous and remarkable manifestations of nature's forces will remain with me as long as memory lasts."

Artist Thomas Moran
recalling his first view of
the Yellowstone area, 1871

DURING THE 19TH CENTURY the United States acquired most of the land that makes up the American West. A single treaty, the Louisiana Purchase, added 830,000 square miles in 1803 and doubled the size of the country. The year 1845 saw the annexation of Texas, and in 1846 the Oregon Treaty with Great Britain ceded much of the Pacific Northwest to the United States. The Mexican War and subsequent Treaty of Guadalupe Hidalgo brought California, New Mexico, Utah, Nevada, and parts of Colorado and Wyoming under U.S. control. In 1867 the United States purchased from Russia the half-million square miles that make up Alaska. Hawaii was annexed in 1898.

In each case, territorial acquisition raised many of the same questions. What were these lands like? Where were their boundaries? What resources did they contain? Who lived there? Was this land suitable for economic development and settlement? To answer these questions, the federal government supported surveys into these areas. Beginning with the Lewis and Clark expedition of 1804–6 and extending into the early 20th century, there were dozens of surveys of the West, usually led by military officers or scientists. Typically, their charge was to make a "reconnaissance" of the lands they explored, noting physical features, drawing maps, securing natural and geological specimens, and investigating the native cultures of the area. The surveyors also took along artists and, after mid-century, photographers who recorded what they saw on paper and on photographic plate. Their views were often the first images most Americans had of the West.

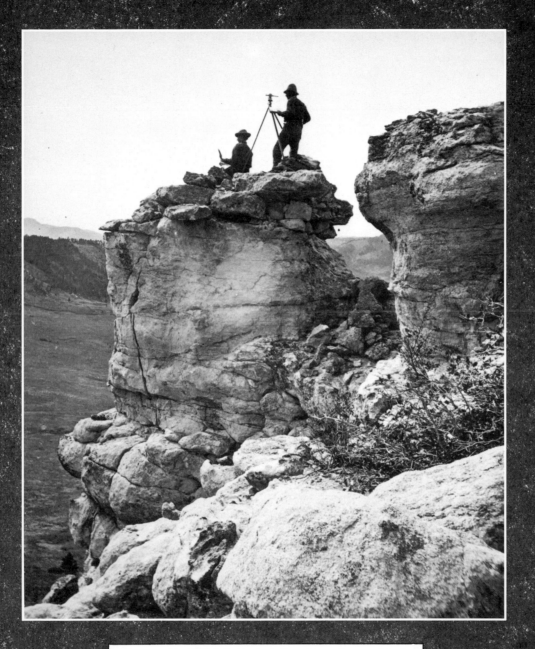

"Topographical Work," 1874, by William Henry Jackson (Hayden Survey). Much survey work involved taking precise readings that would later depict the lay of the land in accurate maps.

RG 57, Records of the Geological Survey (57-HS-1112)

EARLY SURVEYS OF THE WEST

IN THE EARLY 19th century little was known about
the lands west of the Mississippi. Because of this lack of
knowledge, western explorations and surveys had many
purposes. Some, like the Lewis and Clark expedition
and the United States Exploring Expedition, were
scientific and topographic expeditions concerned with
collecting geological, botanical, and wildlife specimens
and preparing maps of previously unexplored territory.
Others, like the U.S. Army Corps of Topographical
Engineers' surveys of potential railroad routes and
wagon roads, were more utilitarian. Surveys could also
have political purposes. Boundary surveys, for example,
could be used to scout out possible fortifications and to
assert U.S. influence along the borders of Mexico and
Canada. Whatever their purposes, the artists who went
along recorded their observations of the land and its
people.

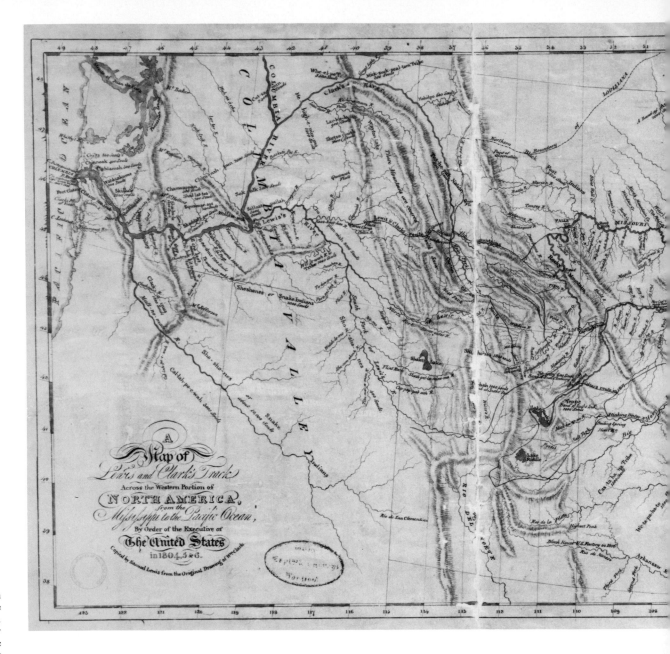

"A Map of Lewis and Clark's Track Across the Western
Portion of North America, from the Mississippi to the Pacific
Ocean, By Order of the Executive of the United States in 1804,
5 & 6. Copied by Samuel Lewis from the Original Drawing by
William Clark," ca. 1812. After the Louisiana Purchase of 1803 more
than doubled the size of the United States, President Thomas
Jefferson sent Meriwether Lewis and William Clark to explore the
lands west of the Mississippi. Their expedition took 2 years and
covered 8,000 miles.

*RG 77, Records of the Office of the Chief of Engineers, Civil Works file,
U.S. 529*

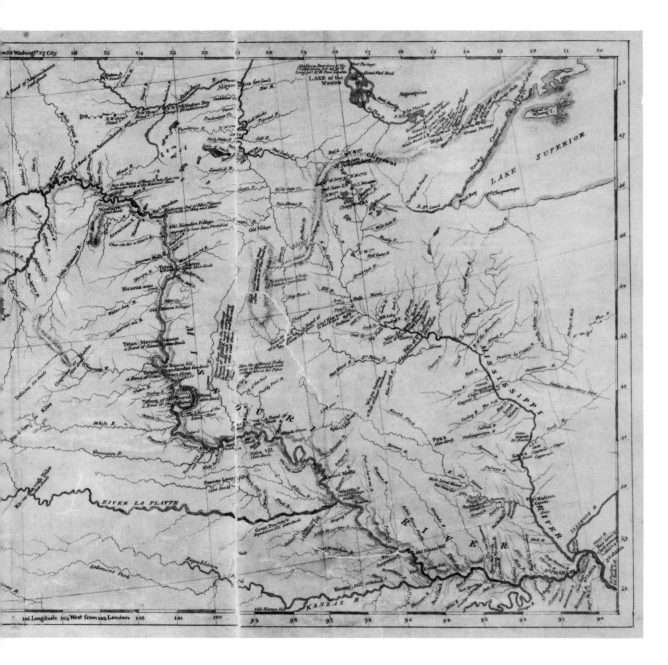

"Opuntia filipendula E.," 1853, by an unknown artist. William Emory included many botanical sketches such as this one in his survey of the southern border of the United States. But Emory's survey also had a political purpose: to accurately survey the newly established boundaries of the United States in the wake of the Mexican War and the Gadsden Purchase of 1853.

RG 76, Records of Boundary and Claims Commissions and Arbitrations, entry 423, number 68

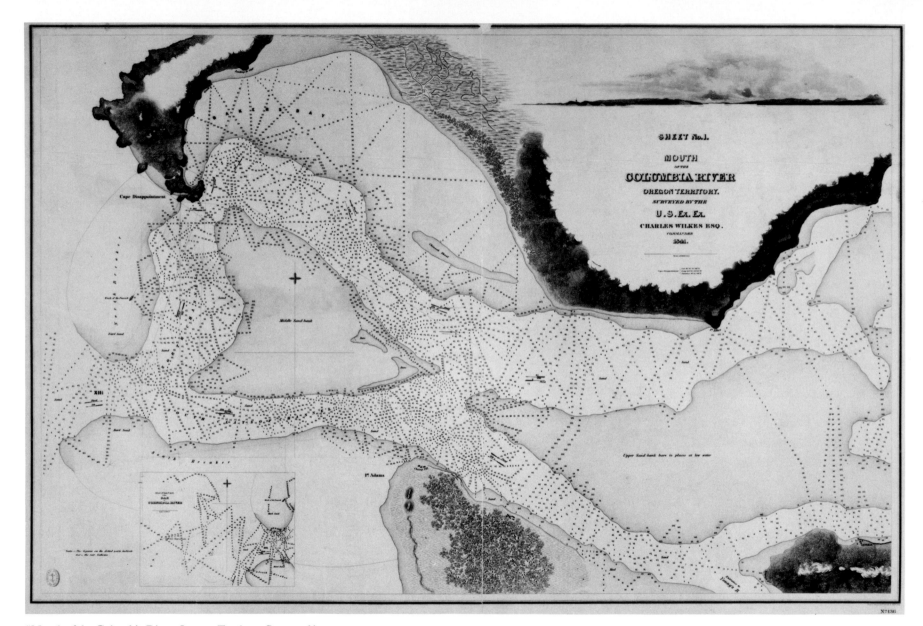

"Mouth of the Columbia River, Oregon Territory Surveyed by the U.S. Ex[ploring] Ex[pedition] Charles Wilkes Esq. Commander 1841." Over 4 years the ambitious United States Exploring Expedition sailed the islands of the South Pacific, the waters around Antarctica, and the rivers along the Pacific Northwest coast.

RG 77, Records of the Office of the Chief of Engineers, Civil Works file, Misc. 30-39

"Esquimalt Harbor from Summit of 'Mill Mountain' near head of bay showing 'Active' and 'Satellite's' anchorage. In the distance Smiths' or Blunts' Island and entrance to Haro and Rosario Straits." 1857–62, by James Madison Alden. As official artist to the Northwest Boundary Survey, which established the border between Canada and the United States, James Madison Alden completed 64 watercolors. His work took over 5 years to complete, but the coming of the Civil War shifted congressional interest away from exploring the West, and the survey's final report was never published. Alden's work remained largely unknown until the 1970s.

RG 76, Records of Boundary and Claims Commissions and Arbitrations, Alden Watercolors, #1

"Lake Bigler from the East," 1859, by J. J. Young, from a sketch by H.V.A. von Beckh. As in the case of the Northwest Boundary Survey's final report, the Civil War stopped publication of J. J. Young's watercolors of James Henry Simpson's survey of Utah.

RG 77, Records of the Office of the Chief of Engineers, Civil Works file, Misc. 120-8

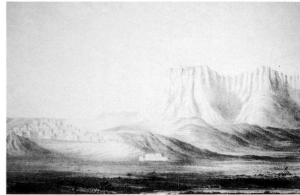

"**Genoa, East Foot of Sierra Nevada,**" 1859, by J. J. Young, from a sketch by H.V.A. von Beckh.

RG 77, Records of the Office of the Chief of Engineers, Civil Works file, Misc. 120-7

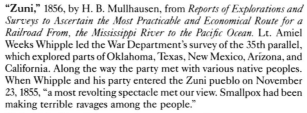

"**Zuni,**" 1856, by H. B. Mullhausen, from *Reports of Explorations and Surveys to Ascertain the Most Practicable and Economical Route for a Railroad From, the Mississippi River to the Pacific Ocean.* Lt. Amiel Weeks Whipple led the War Department's survey of the 35th parallel, which explored parts of Oklahoma, Texas, New Mexico, Arizona, and California. Along the way the party met with various native peoples. When Whipple and his party entered the Zuni pueblo on November 23, 1855, "a most revolting spectacle met our view. Smallpox had been making terrible ravages among the people."

National Archives Library

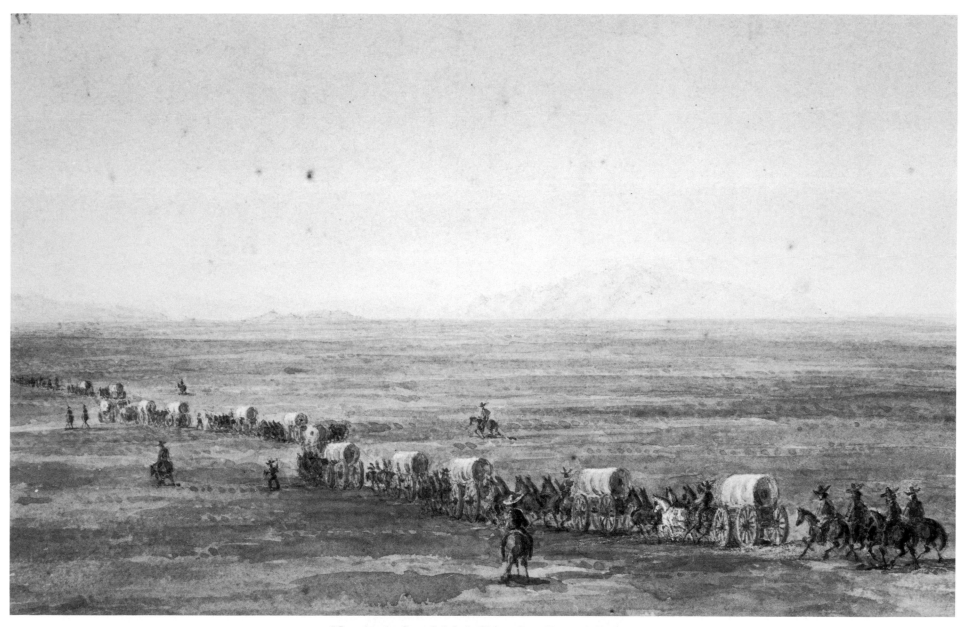

**"Crossing the Great Salt Lake Desert from Simpson's Spring
to Short Cut Pass, Granite Mountain in the Distance,"** 1859, by
J. J. Young, from a sketch by H.V.A. von Beckh.
*RG 77, Records of the Office of the Chief of Engineers, Civil Works file,
Misc. 120-1*

THE GREAT SURVEYS

THE CIVIL WAR brought a halt to most surveying, but after the North's victory, the federal government once again enthusiastically supported further exploration. As the United States grew, it urgently needed information about the West's climate, natural resources, geography, and settlement patterns. While federal sponsorship of surveys once again supported scientific research and publication, the data was of more than academic interest. The information helped railroads to locate routes, homesteaders to plan farms, and mining companies to search for mineral deposits.

Between 1867 and 1879 the four "Great Surveys" of the American West moved across the country. Known to the public by the names of their leaders, Ferdinand V. Hayden, Clarence King, George Wheeler, and John Wesley Powell, these expeditions explored much of the Mountain West, accumulated a large body of scientific data, mapped the land, collected geological and botanical specimens, and provided extensive documentation. The immensely talented photographers and artists who joined the expeditions created a compelling record of their travels.

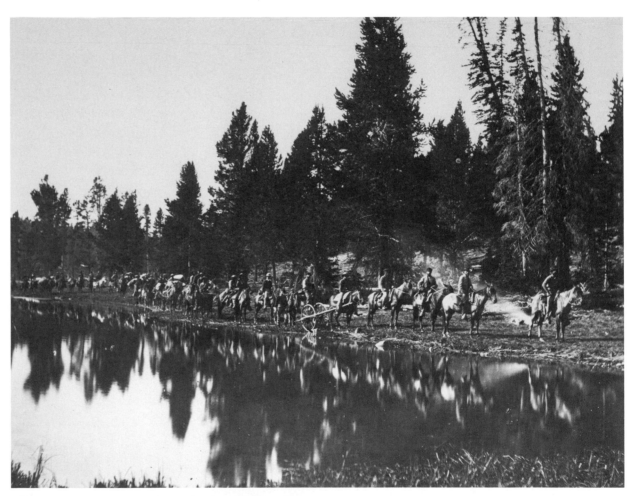

"The Geological Survey en Route," 1871, by William Henry Jackson (Hayden Survey). The Hayden Survey, 1867–78, explored Nebraska, Wyoming, Colorado, Idaho, Montana, New Mexico, and Utah. This photograph was taken as the survey party entered Yellowstone.
RG 57, Records of the Geological Survey (57-HS-114)

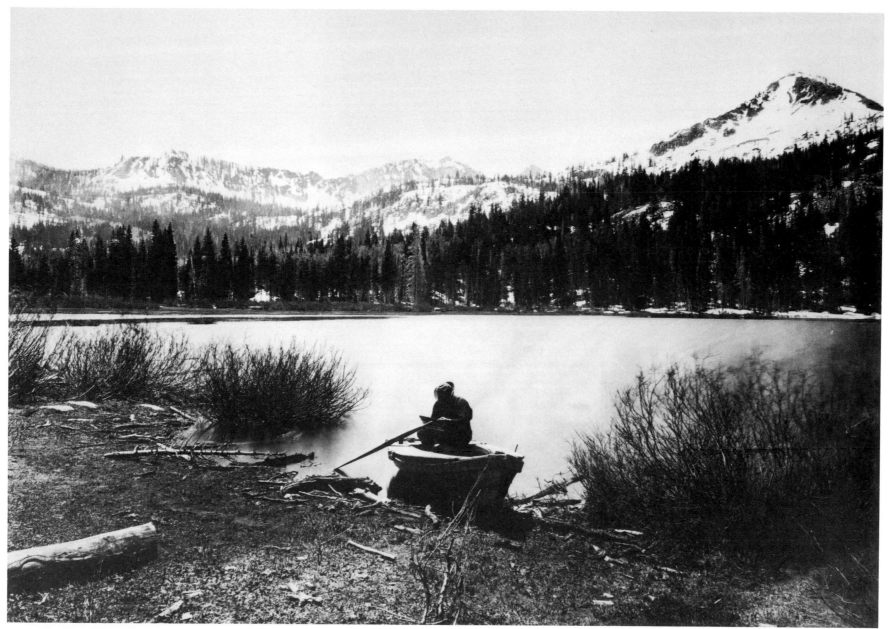

"Cottonwood Lake, Wahsatch Mountains, Utah," 1869, by
Timothy O'Sullivan (King Survey).
RG 77, Records of the Office of the Chief of Engineers (77-KN-153)

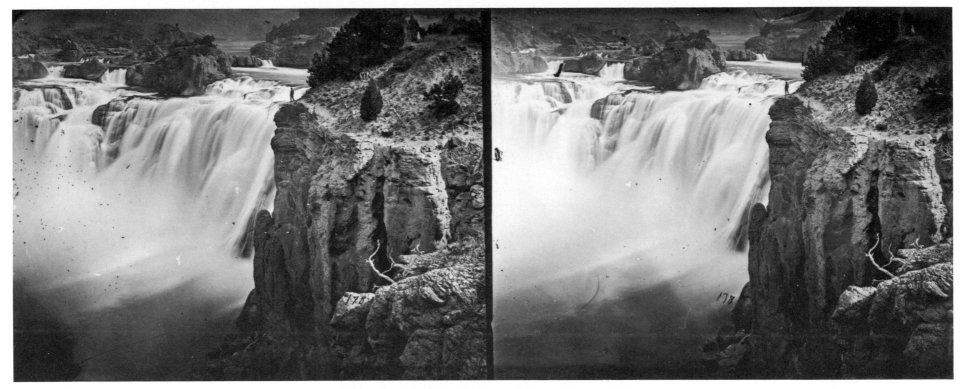

"Shoshone Falls, Idaho," 1868, by Timothy O'Sullivan (King Survey). This stereo view of Shoshone Falls was one of a series of the falls done from a number of perspectives. While the photographs convey a sense of the falls' grandeur, their purpose was to show the falls as a geological formation.

RG 77, Records of the Office of the Chief of Engineers (77-KW-178)

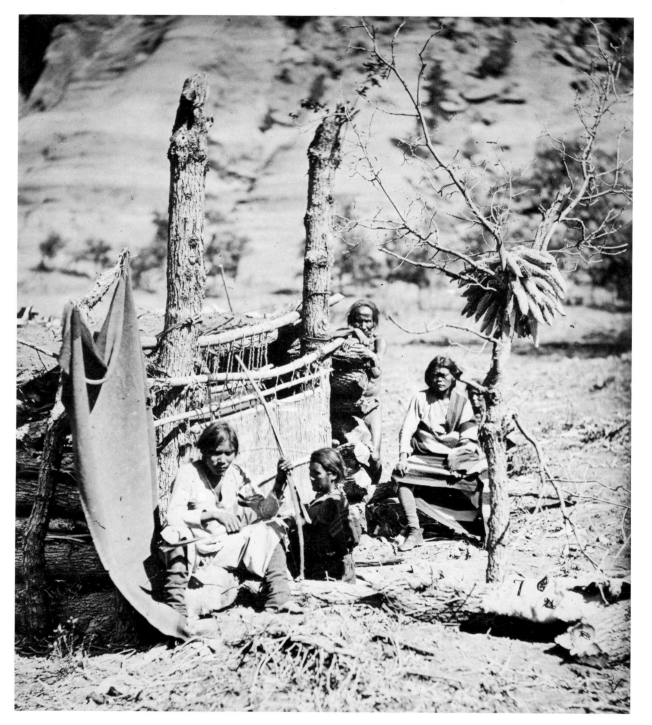

"Shaft Mouth at Mining Works, Virginia City, Nevada, 1867–68," by Timothy O'Sullivan (King Survey). Survey photographers produced images of more than geological formations, camp scenes, and landscapes. They also documented social and economic change. Their views showed mines, farms, and towns as well as the lifestyles of native cultures.

RG 77, Records of the Office of the Chief of Engineers (77-KSP-11)

"Aboriginal Life Among the Navajoe Indians near old Fort Defiance, New Mexico," 1873, by Timothy O'Sullivan (Wheeler Survey).

RG 106, Records of the Smithsonian Institution (106-WB-305)

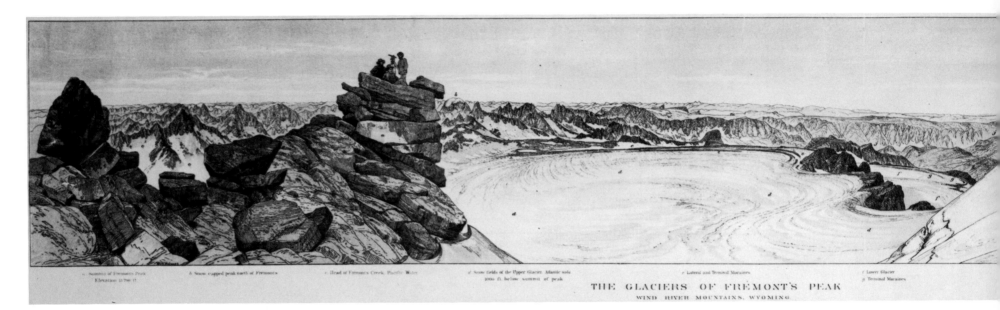

THE GLACIERS OF FREMONT'S PEAK
WIND RIVER MOUNTAINS, WYOMING

"Panoramic Views," ca. 1877, by William Henry Holmes (Hayden Survey). Lithograph by Julius Bien, from F. V. Hayden, *Atlas of Wyoming, Idaho, and Utah* (detail).
RG 57, Records of the Geological Survey

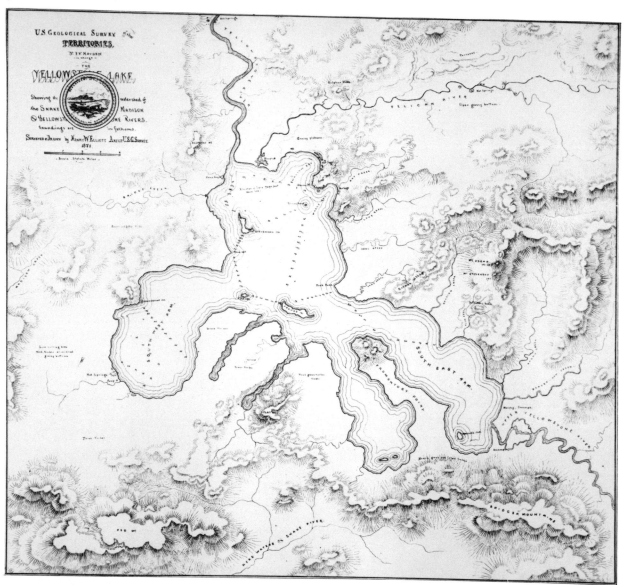

"The Yellowstone Lake Showing the Watershed of the Snake,
Madison, and Yellowstone Rivers," 1871, by Henry W. Elliott
(Hayden Survey).

RG 77, Records of the Office of the Chief of Engineers, Q-392 #9

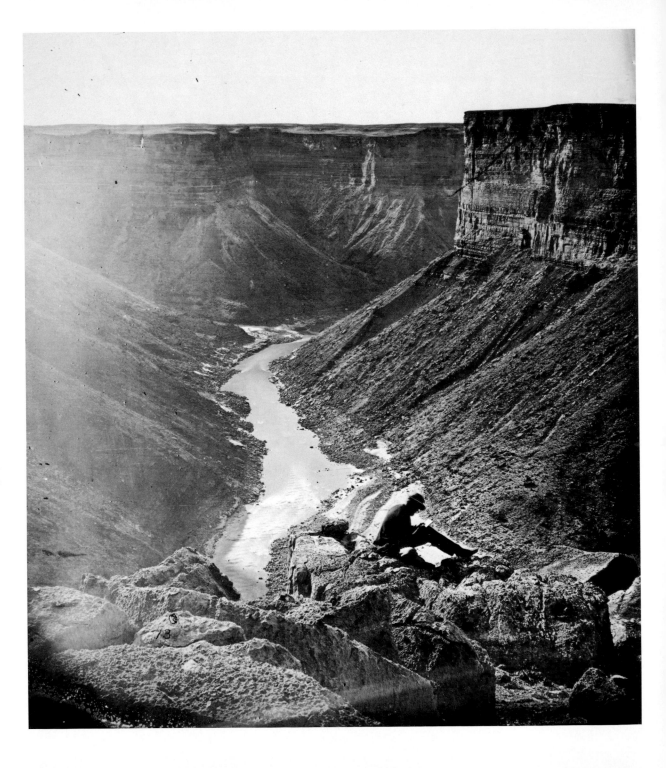

"Grand Cañon of the Colorado, Mouth of the Kanab Wash, Looking West," 1872, by William Bell (Wheeler Survey). The Great Surveys included artists who sketched geological formations. The Wheeler Survey explored Death Valley and the Colorado River. This photograph was mistitled. Actually, the view is looking south from Marble Canyon.

RG 106, Records of the Smithsonian Institution (106-WB-276)

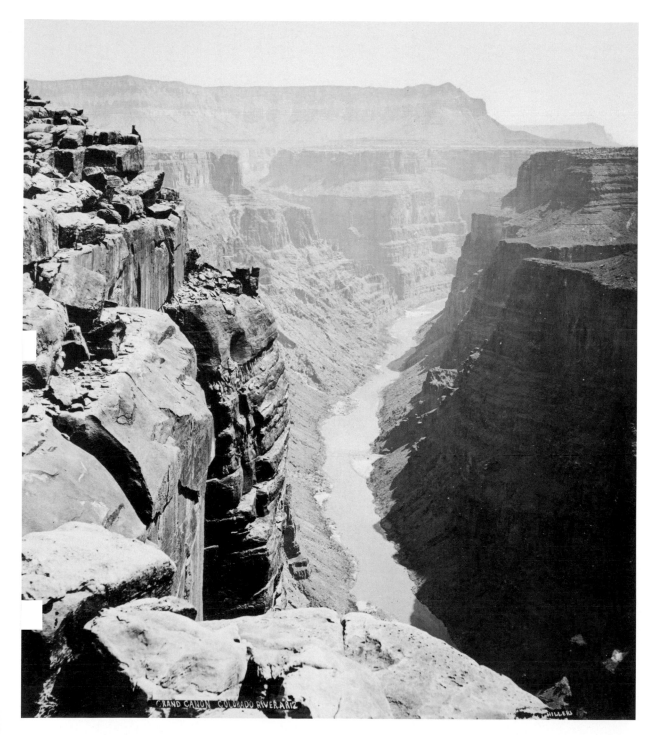

"Aquarius Plateau. J. K. Hillers at Work," Utah, 1872, by an unknown photographer (Powell Survey). Nineteenth-century survey photography was difficult and time consuming. Photographers had to carry heavy and fragile glass plate negatives and other equipment up mountains, along canyon gorges, and across deserts.

RG 57, Records of the Geological Survey (57-PS-809)

"Grand Canyon," Coconino and Mohave Canyon, Arizona, ca. 1873, by John K. Hillers (Powell Survey).

RG 57, Records of the Geological Survey (57-PS-66)

ALASKA AND HAWAII

EXPLORATIONS of the West have not been limited to the continental United States. When the United States purchased Alaska in 1867, this huge territory and its vast resources were mostly unknown. Similarly, expansion across the Pacific in the mid-19th century piqued American interest in the Pacific islands, especially those of Hawaii. While these areas are certainly different in many ways from the rest of the American West, they share with it a common heritage of government-sponsored surveys. With these surveys came images of the new lands: beautiful coastlines, huge mountains, different cultures, and exotic plants and animals.

"Diamond Head, Honolulu, H.[awaiian] I.[slands], 1866," by an unidentified artist from the crew of the U.S.S. *Vanderbilt.* After the Civil War, the U.S. Navy initiated a series of scientific surveys of the Pacific Ocean. Among the records of these surveys are several sketches of the Hawaiian landscape.

RG 37, Records of the Hydrographic Office, file 273.3

"Alaskan Jay Perisoreus canadensis fumifrons," 1886, by Robert Ridgeway, from L. M. Turner, *Contributions to the Natural History of Alaska.* Amateur naturalist Lucien Turner sent thousands of specimens of birds, plants, and animals to the Smithsonian Institution during the years he spent in Alaska as a U.S. Army meteorologist. His report on Alaskan wildlife was illustrated with Robert Ridgeway's marvelous paintings of native birds.

National Archives Library

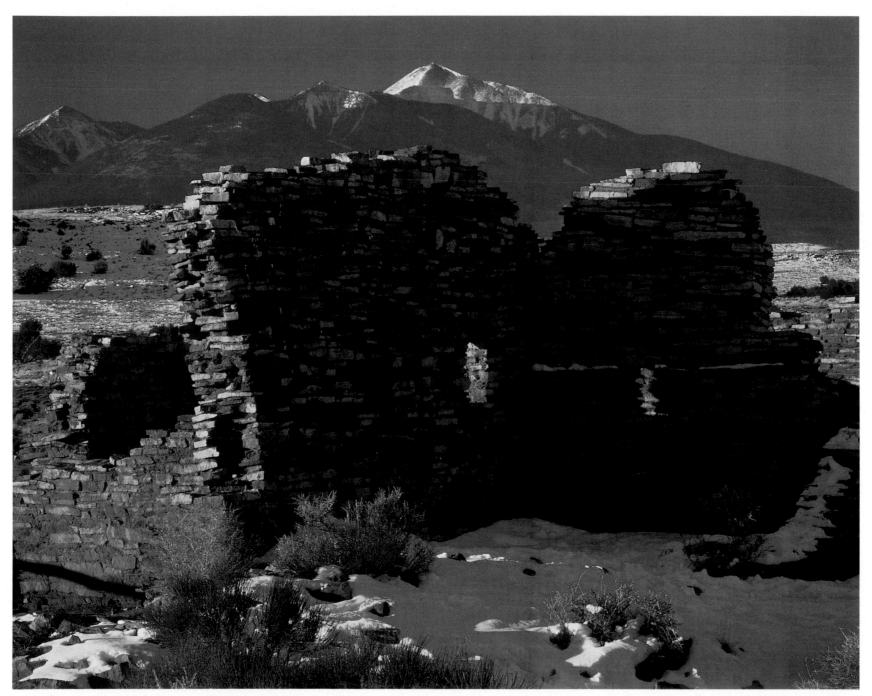

"Wupatki National Monument . . ." © Tom Till. *See page 8.*

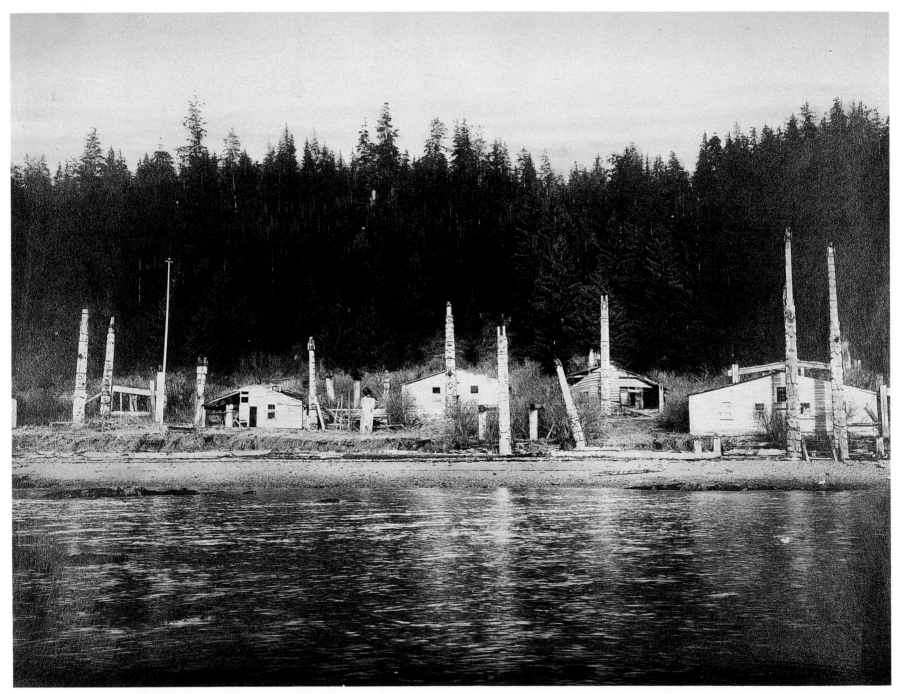

"Old Kasaan, Alaska." *See page 12.*

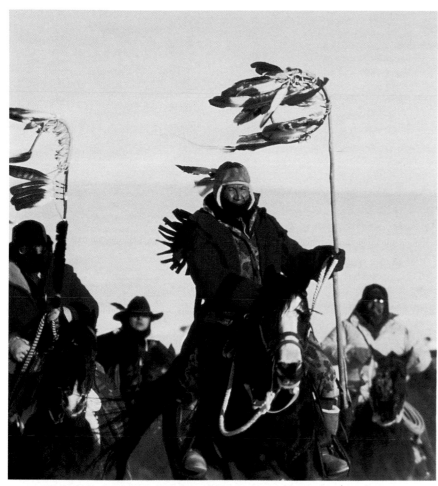

"100th Anniversary Ride." © Allen Russell/Profiles West. *See page 31.*

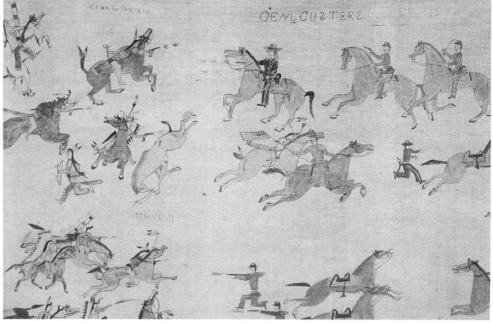

Pictograph of the Battle of the Little Big Horn. *See page 19.*

"Zuni." See page 60.

"Esquimalt Harbor . . ." *See page 59.*

"Lake Bigler from the East." *See page 59.*

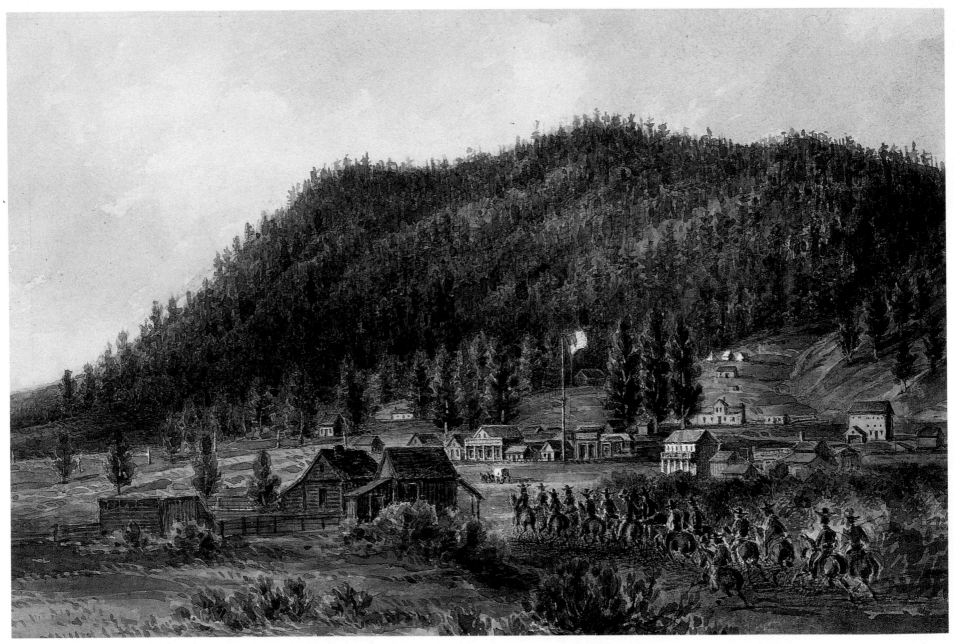

"Genoa, East Foot of Sierra Nevada." *See page 60.*

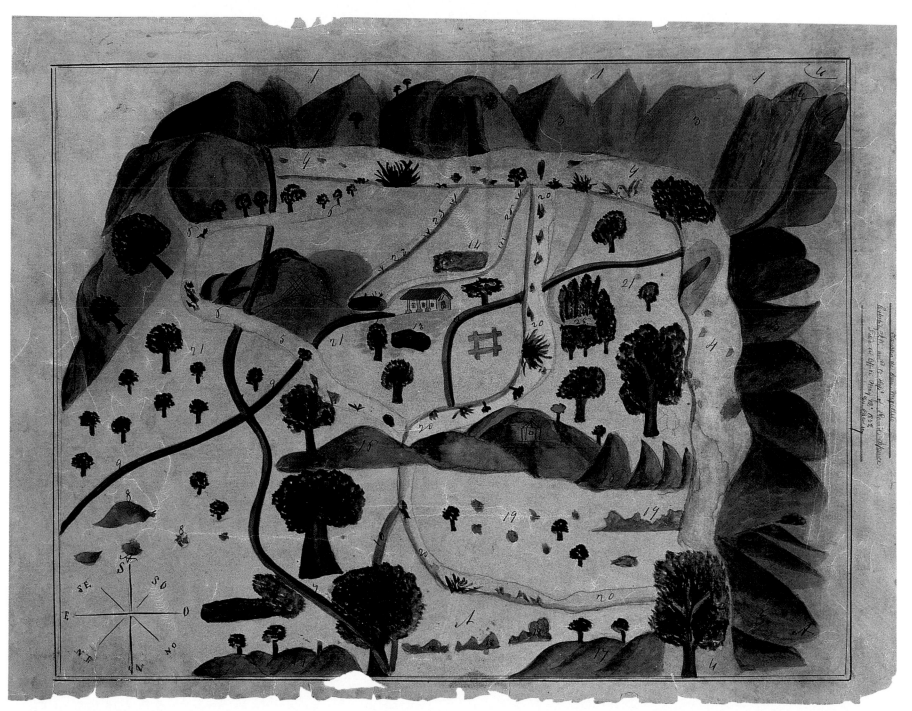

"Rancho San Miguelito . . ." *See page 76.*

"Alaskan Jay . . ." *See page 70.*

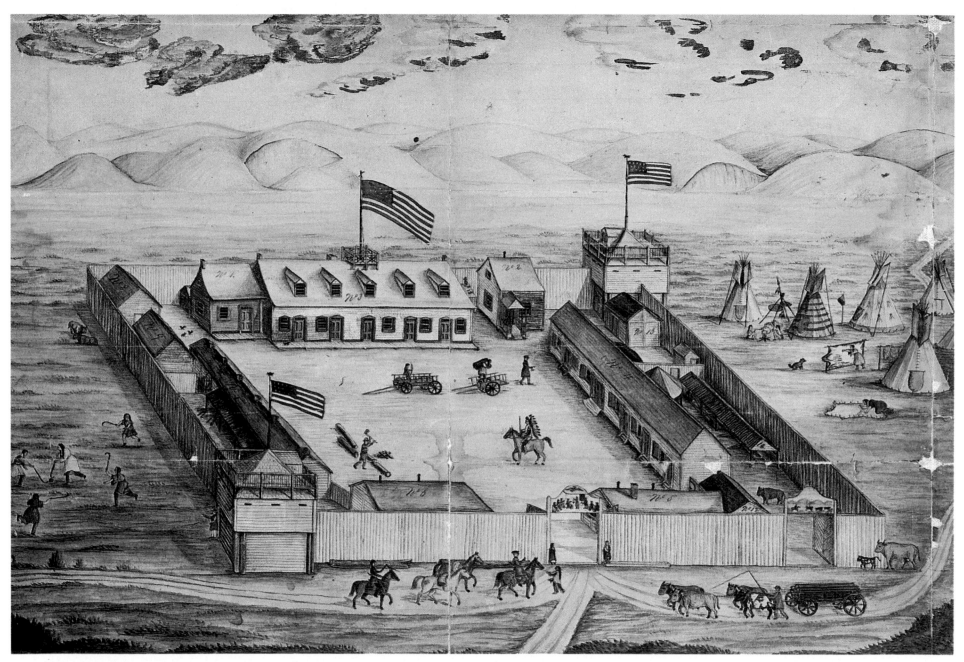

"View of Fort Pierre." *See page 78.*

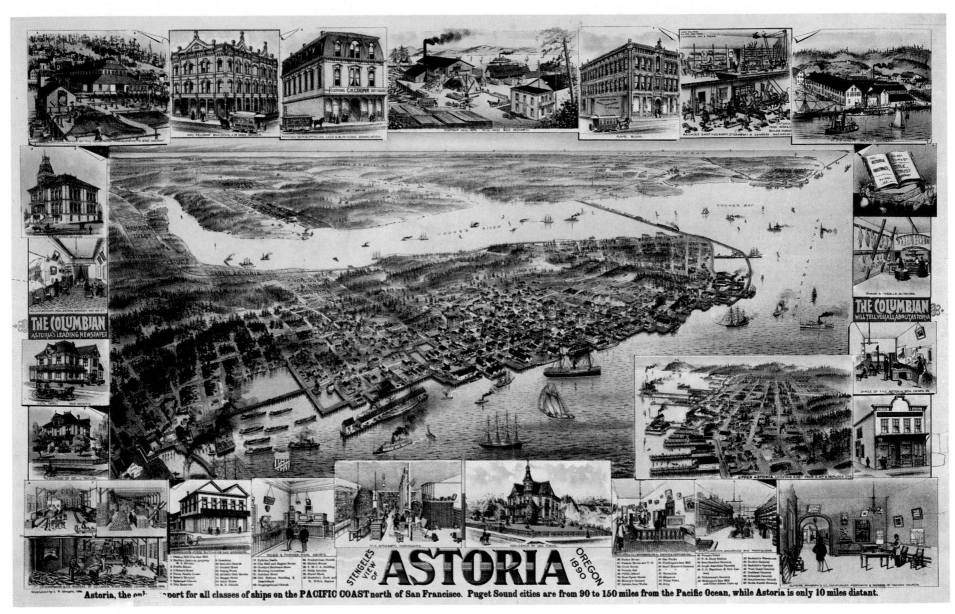

Astoria, the only port for all classes of ships on the PACIFIC COAST north of San Francisco. Puget Sound cities are from 90 to 150 miles from the Pacific Ocean, while Astoria is only 10 miles distant.

"Stengele's View of Astoria . . ." *See page 86.*

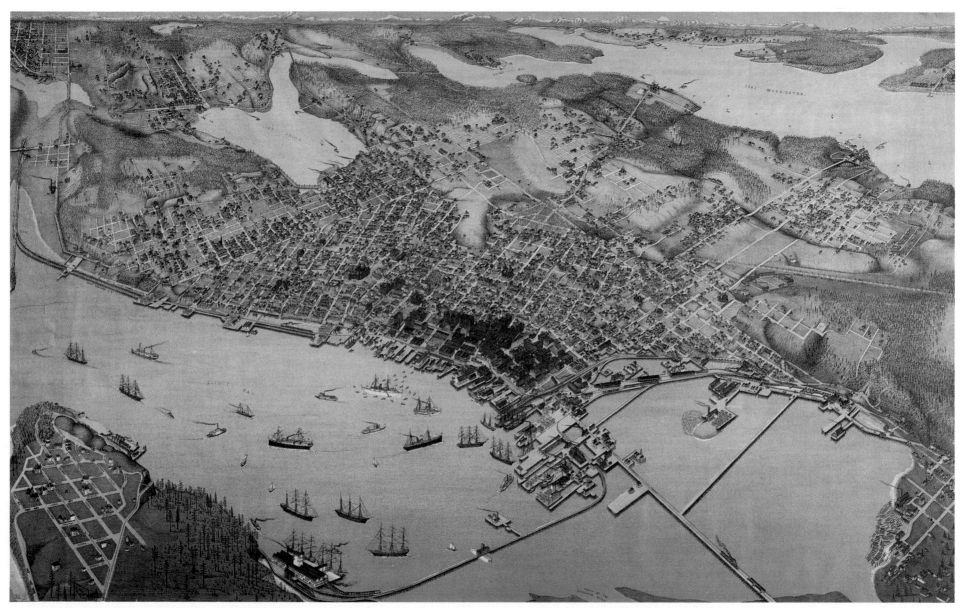

"Birds Eye View of Seattle and Environs . . ." *See page 87.*

"Thunderbird Display . . ." *See page 85.*

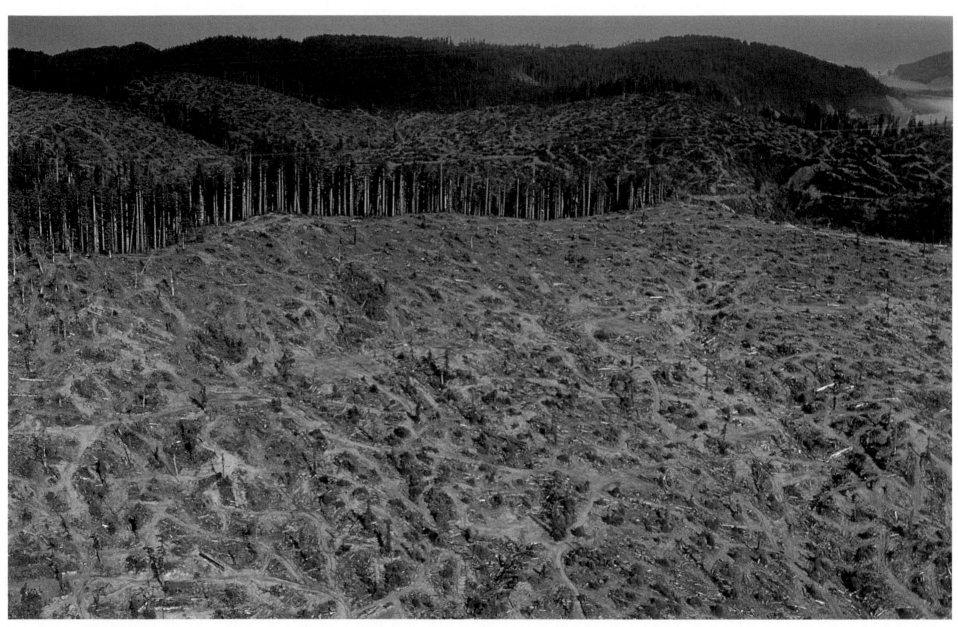

"Clear Cutting." *See page 110.*

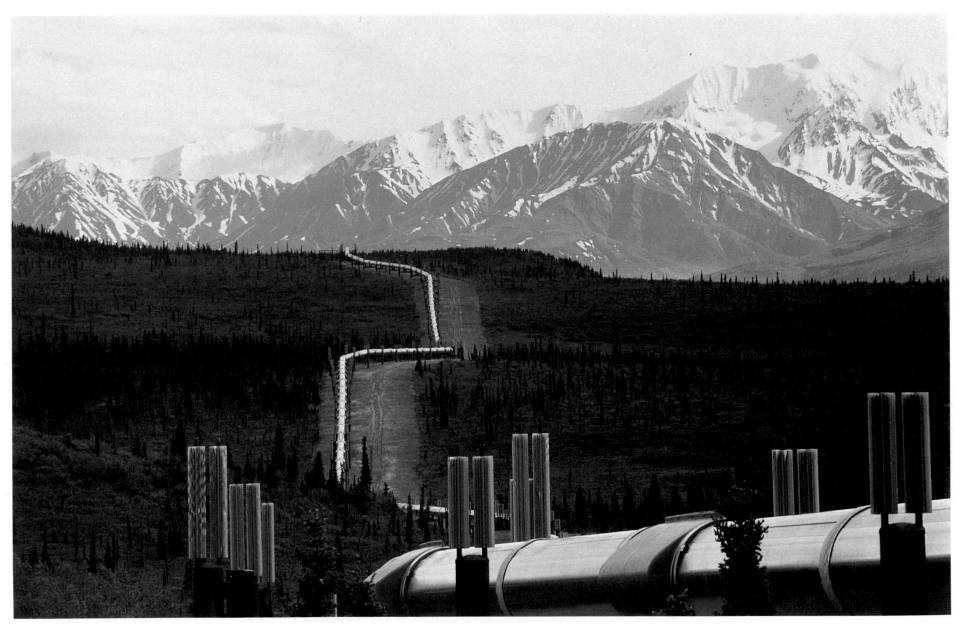

"Pipeline, Alaska Range . . ." © George Wuerthner. *See page 111.*

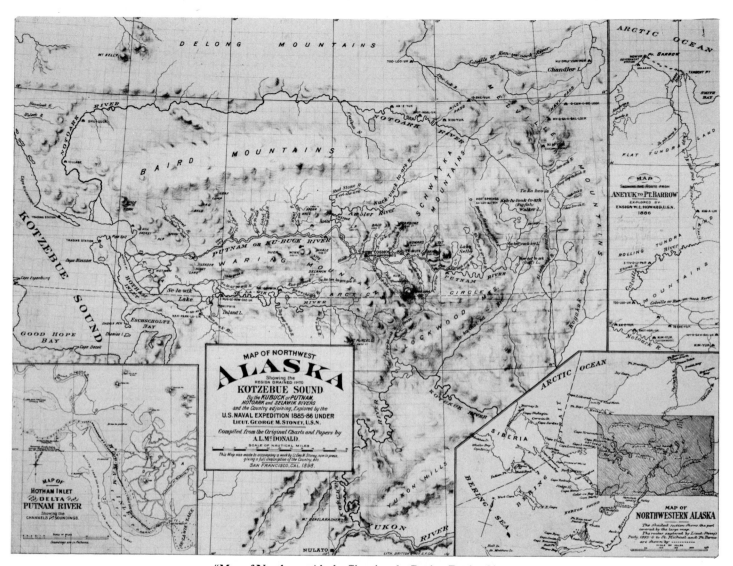

"Map of Northwest Alaska Showing the Region Drained into Kotzebue Sound by the Kubuck or Putnam, Notoark and Selawik Rivers and the Country adjoining, Explored by the U.S. Naval Expedition 1885–86 Under Lieut. George M. Stoney, U.S.N. Compiled from the Original Charts and Papers by A. L. McDonald," San Francisco, 1898. From 1884 through 1886, U.S. Navy Lt. George M. Stoney explored several northwestern Alaska rivers. His largest expedition up the Kubuck during 1885 and 1886 included 2 steamboats, 18 men with provisions for 20 months, and a portable sawmill. He also provided his men with mesh hoods for protection against Alaskan mosquitoes.

RG 37, Records of the Hydrographic Office, Archives Section (1838–1908), 1101.11

71

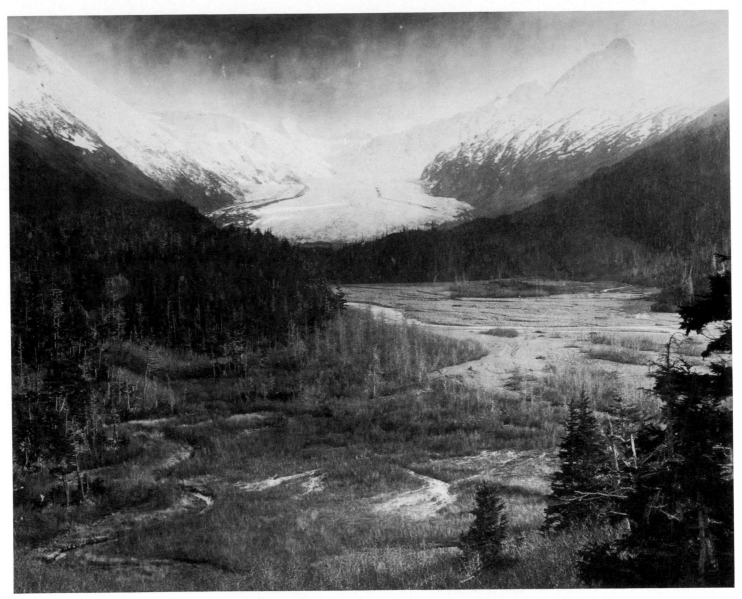

"View of Glacier from Mile 46," October 20, 1918, by Henry G. Kaiser. After a commission appointed by President William Howard Taft recommended that a railroad be built between Seward and Fairbanks, the federal government surveyed, planned, and constructed it. The Alaska Railroad, completed in 1923, was the first federally constructed and owned railroad in the United States.

RG 126, Records of the Office of Territories (126-AR-6G-2B)

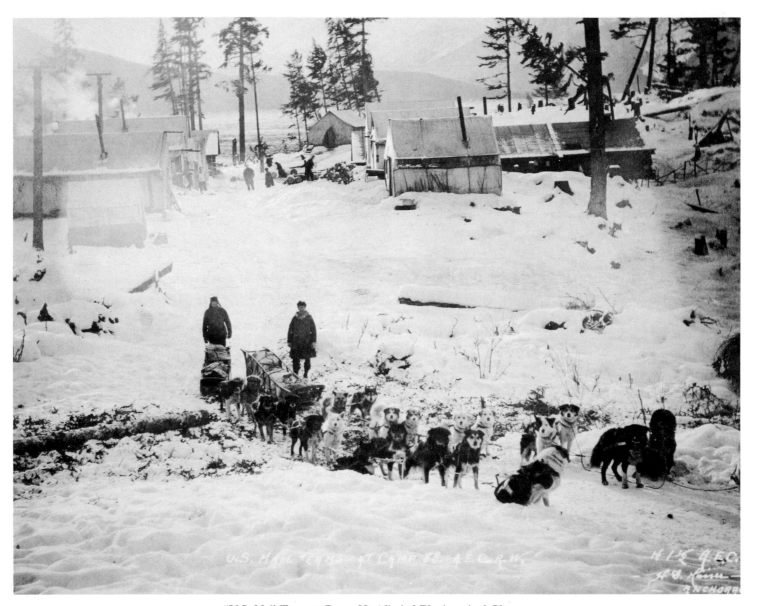

"U.S. Mail Team at Camp 88, A[laska] E[ngineering] C[ommission] R[ail] W[ay]," Alaska, ca. 1918, by Henry G. Kaiser. The Alaskan Railroad stretches almost 500 miles. Its construction created the city of Anchorage as well as several smaller towns along the route.

RG 126, Records of the Office of Territories (126-AR-12B-1)

Towns, Cities, and Communities

"SETTLING THE WEST" conjures up images of isolated individ-
uals and families struggling in the wilderness. But there was also an
"urban frontier" that changed the West and its way of life. Regional
centers such as Salt Lake City, San Francisco, and Portland became
hubs of commerce, transportation, and newspaper publishing. Smaller,
but nonetheless ambitious, towns evolved from old forts, missions,
trading posts, and mining camps. A few of these thrived, but many fell
victim to the harsh swings of the West's economic cycles.

Successful or not, western cities, both large and small, faced similar
challenges. They needed streets, homes, schools, businesses, churches,
and governments. They also needed the sense of community and
stability that would make the West home.

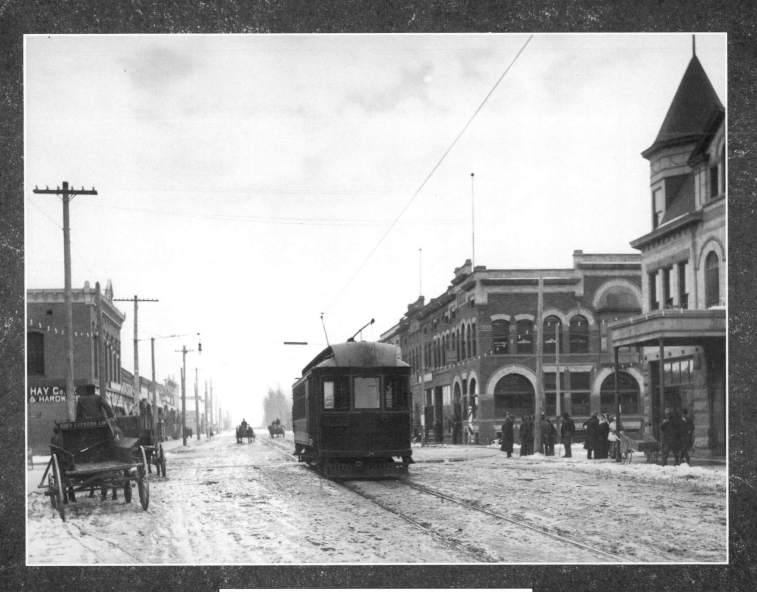

"Interurban cars running through Main Street of Caldwell,"
Idaho, February 21, 1910, by Walter J. Lubken. Bureau of Reclamation
photographer Walter J. Lubken moved around the early 20th-century
West photographing reclamation projects and the impact of projects
on towns such as Caldwell, Idaho.

RG 115, Records of the Bureau of Reclamation (115-JC-305)

FIRST SETTLEMENTS

AS EARLY AS 300 B.C., Native Americans began to establish a network of cities in the American Southwest that eventually stretched from present-day Mexico north to southern Colorado and Utah. Spanish-speaking colonists created settlements such as Santa Fe and San Diego. Other settlers, lured across the continent from the East by visions of land, gold, religious freedom, or other opportunities, followed in the mid-19th century, building towns such as Salt Lake City and Denver.

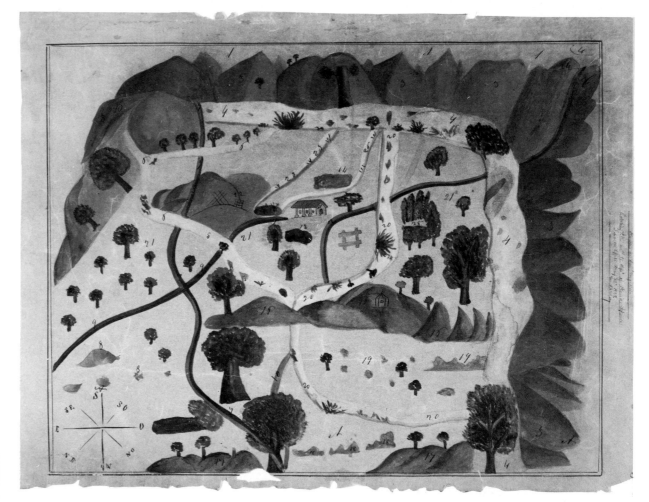

"Rancho San Miguelito, California," 1852, by José Rafael Gonzales. After the Mexican War, Spanish landowners in areas ceded to the United States from Mexico filed illustrated plats, called "diseños," to prove ownership of their land to the federal government.

RG 49, Records of the Bureau of Land Management, California Private Land Claims, vol. 1

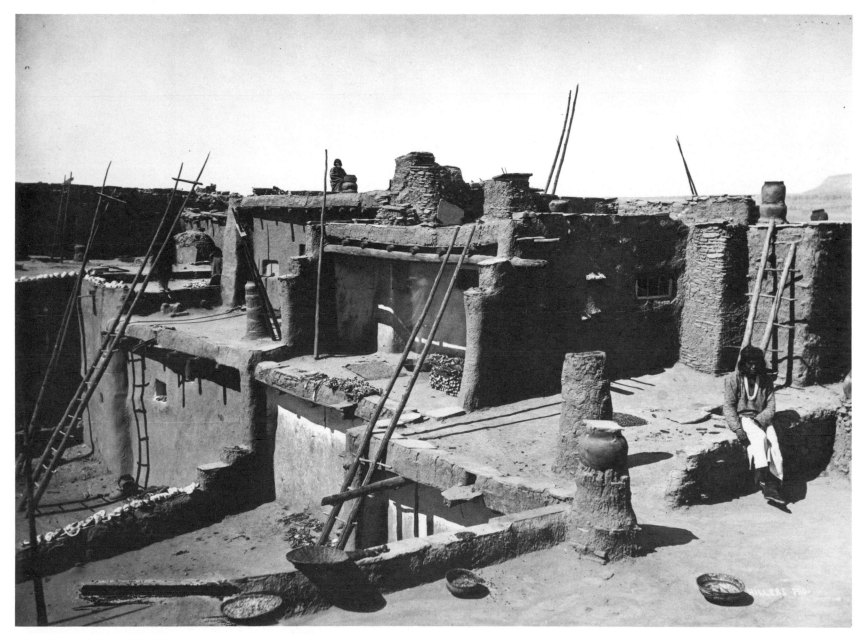

"Old Zuni," 1879, by John K. Hillers. In the late 17th century the residents of seven Zuni pueblos encountered Spanish soldiers who conquered them and moved them to the site of present-day Zuni pueblo.

RG 106, Records of the Smithsonian Institution (106-IN-2384)

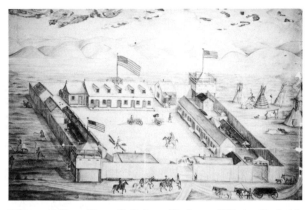

"View of Fort Pierre," Dakota Territory, 1855, by Frederick Behman. In 1855 Frederick Behman painted this watercolor of Fort Pierre while he was employed by the Chouteau Fur Trading Company. The company submitted Behman's painting to the War Department during negotiations that resulted in the sale of the trading post to the federal government.

RG 92, Records of the Office of Quartermaster General

"Gayville in Deadwood Gulch, Black Hills," Dakota Territory, 1876, by an unknown photographer. The discovery of gold in the Black Hills of the Dakota Territory in 1874 led to a "gold rush" and to the growth of boomtowns like Deadwood.

RG 111, Records of the Office of the Chief Signal Officer (111-SC-100863)

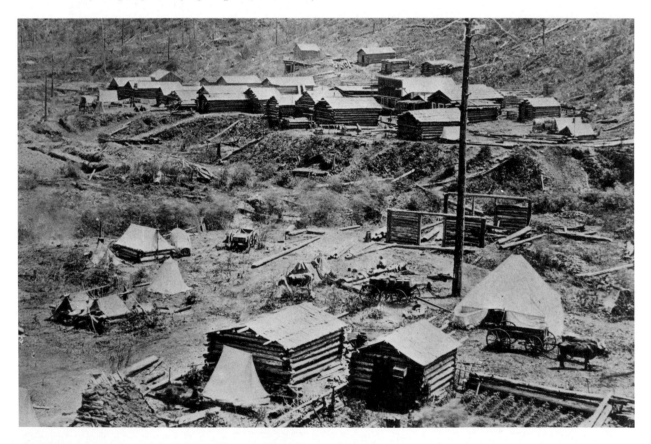

BUILDING COMMUNITY

MOVING to the West might have offered new settlers a fresh start, but it did not necessarily mean abandoning old ways of organizing society. Instead, old institutions were often transferred to new surroundings and then adapted to meet the needs of life in a new place.

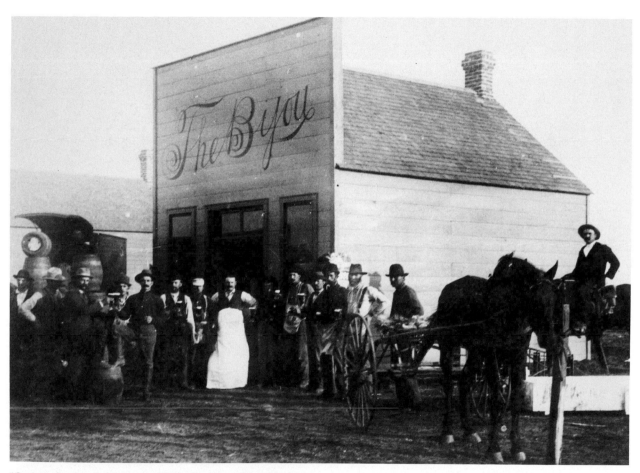

"Gathered around the kegs at Kelley's saloon 'The Bijou,'" Round Pound, Oklahoma Territory, January 1894, by Mr. and Mrs. Robert Kennett. In 1894 the town of Round Pound, Oklahoma, submitted a series of photographs to the House of Representatives Committee on Territories in an effort to prove that Round Pound was a viable town and entitled to have a railroad station.

RG 233, Records of the U.S. House of Representatives (233-TRP-43)
Reproduced with the permission of the House of Representatives

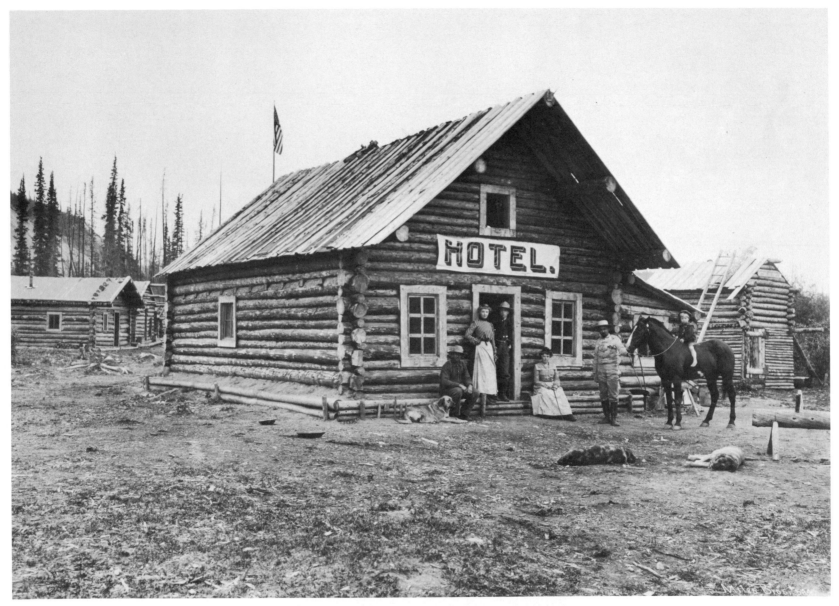

"Loomis Hotel, Tonsina City," Alaska, 1903, by Miles Brothers.
The Valdez, Copper River, and Yukon Railroad contracted with Miles
Brothers, a San Francisco photography studio, to produce this and
other images of life along Alaskan railroad lines.

RG 111, Records of the Office of the Chief Signal Officer (111-AGD-44)

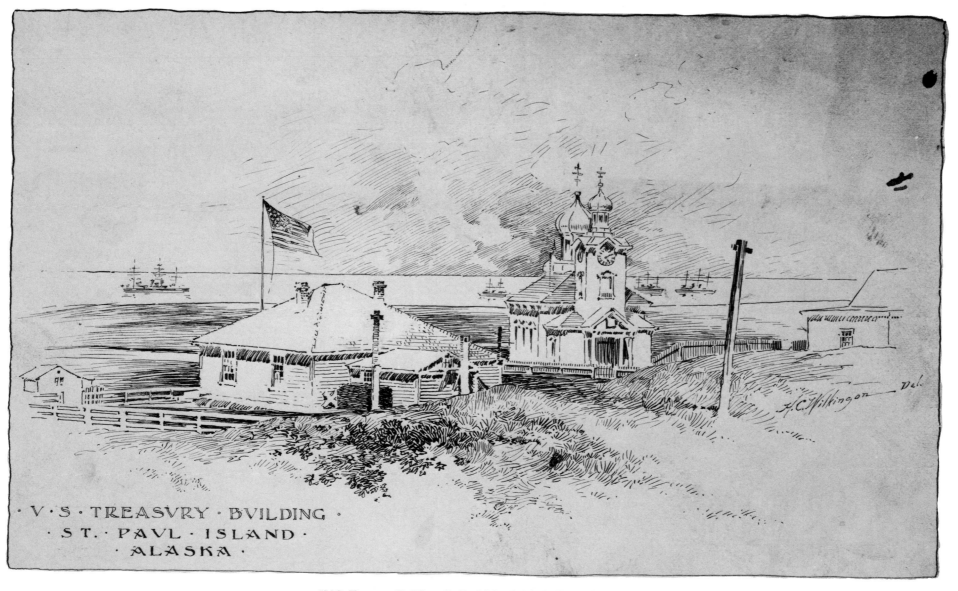

·V·S· TREASVRY· BVILDING·
·ST·PAVL·ISLAND·
·ALASKA·

"U.S. Treasury Building, St. Paul Island, Alaska," ca. 1880, by
H. C. Wilkingon. This onion-domed church next to a U.S. Treasury
station on the Pribilof Islands off Alaska's southwest coast in the
Bering Sea testifies to the Russian influence in Alaska as well to the
pervasive federal presence in the American West.

RG 121, Records of the Public Buildings Service

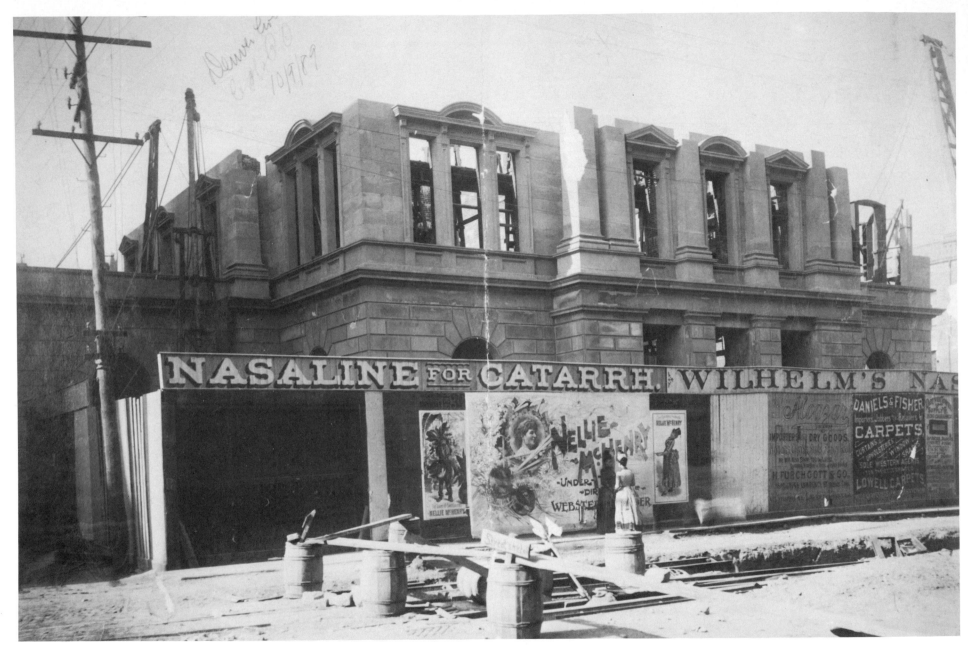

Denver Court House and Post Office, October 9, 1889, by an unknown photographer.

RG 121, Records of the Public Buildings Service, National Archives–Rocky Mountain Region

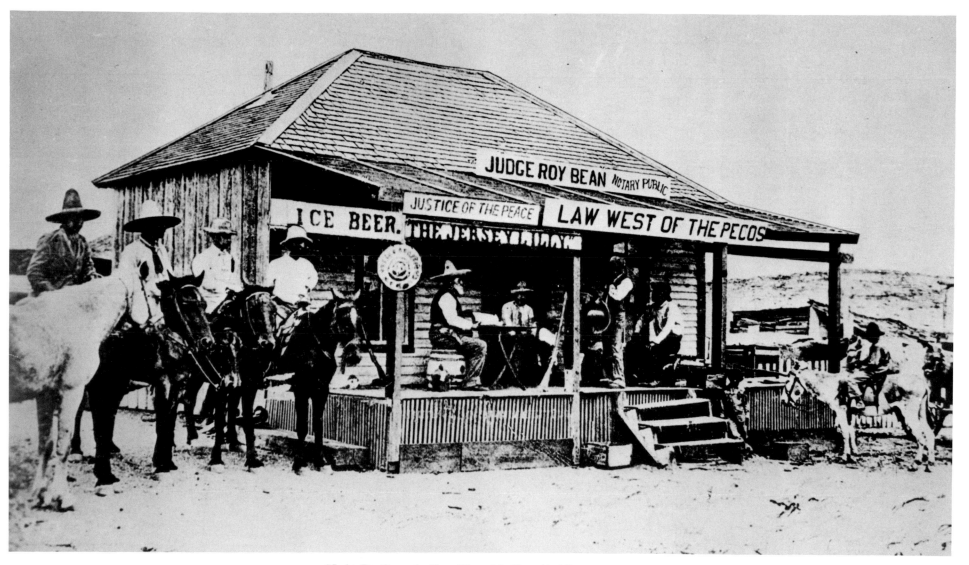

"Judge Roy Bean, the 'Law West of the Pecos,' holding court at the old town of Langtry, Texas in 1900, trying a horse thief. This building was courthouse and saloon. No other peace officers in the locality at the time," 1900, by an unknown photographer. Saloon owner and Justice of the Peace Judge Roy Bean became a national celebrity when stories about his harsh and sometimes bizarre judgments were reported. Bean once fined a dead man $40 for carrying a concealed weapon.

RG 111, Records of the Office of the Chief Signal Officer (111-SC-93343)

"Commercialized entertainment in the village is confined to the movie house, which has films only once every two weeks, and the pool hall, which is looked down upon by many of the community's most substantial citizens. Nevertheless, there are generally a few players to be seen here in the evenings and a particularly large group on Saturday night." Shelby County, Iowa, May 2–7, 1941, by Irving Rusinow. In 1941 the Bureau of Agricultural Economics hired Irving Rusinow to photograph several communities to illustrate a series of studies completed by bureau sociologists. Rusinow's sensitive photographs showed the impact of depression, drought, technology, and the pull of the city on rural life.

RG 83, Records of the Bureau of Agricultural Economics (83-G-44220)

"The Cliff House, San Francisco, 1901," by Henry G. Peabody.
RG 79, Records of the National Park Service (79-HPA-3-53900)

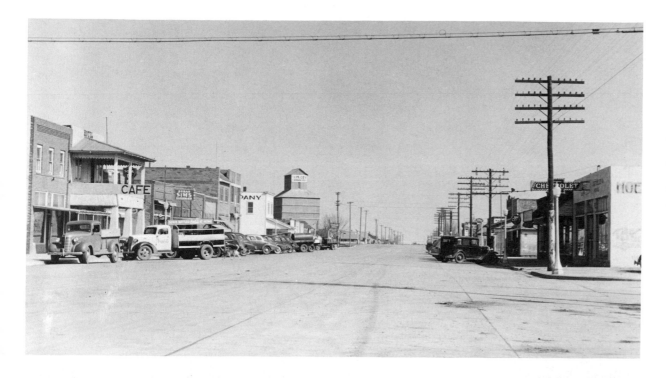

"Sublette is the County Seat of Haskell County. This is its Main Street and Business Section. Notice that most of the cars are new. In the late twenties, when there was rain and the prices were high, most of the cars were Packards and Buicks." Sublette, Kansas, April 1941, by Irving Rusinow. A prospering center of wheat production in the 1920s, Haskell County was hard hit by the "black blizzard" duststorms of 1935. During the 1930s the county lost one-quarter of its 1930 population.

RG 83, Records of the Bureau of Agricultural Economics (83-G-41886)

"Thunderbird Display in Spanish-speaking 2nd ward. South El Paso, Texas, July 1972," by Danny Lyon. In Mexico, "chicano" was a slur meaning "country hick." During the 1960s young, politically active Mexican Americans adopted the term, changing it to a term of pride in Mexican-American heritage and culture.

RG 412, Records of the Environmental Protection Agency (412-DA-2830)

BOOMTOWNS AND BOOSTERS

FOR EVERY successful western city or town, there were several that boomed and then went bust. Mining rushes, land booms, and other types of short-term economic growth contributed to this phenomenon, as did natural disasters and poor location. Such instability, however, never prevented boosters from extolling the advantages of their town and imagining it as the next San Francisco or Denver. Today, much of the West has become thoroughly urbanized, but the contrasts between thriving city and isolated town and between sprawling suburb and abandoned ghost town remain striking.

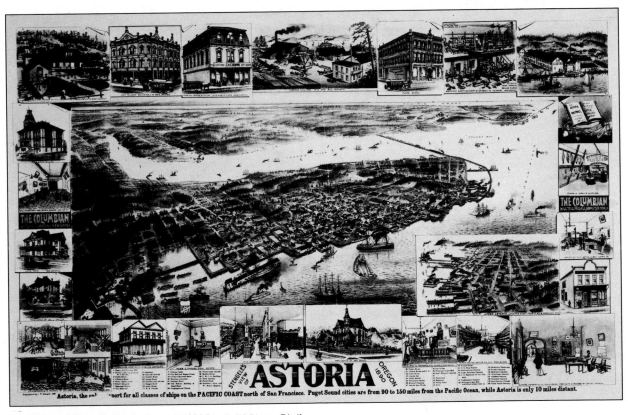

"Stengele's View of Astoria Oregon 1890," by B. W. Pierce. Bird's-eye views were colorful, if somewhat fanciful, town plans designed to impress visitors with a town's social and economic progress. Details such as busy ports, well-laid-out streets, and insets showing fine homes and flourishing businesses conveyed a message of prosperity and permanence to those considering settling or doing business there.

RG 77, Records of the Office of the Chief of Engineers, Civil Works file, CONS 877-4

"Birds Eye View of Seattle and Environs Eighteen Months after the Great Fire, King County, Wash., 1891," by Augustus Koch. By the late 1800s there were bird's-eye views of many western towns and cities. Usually they were drawn by traveling artists like the Prussian immigrant Augustus Koch, who visited 23 states and produced 110 known lithographs between 1868 and 1898.

RG 77, Records of the Office of the Chief of Engineers, Civil Works Numbered Series, #2900, Roll #3

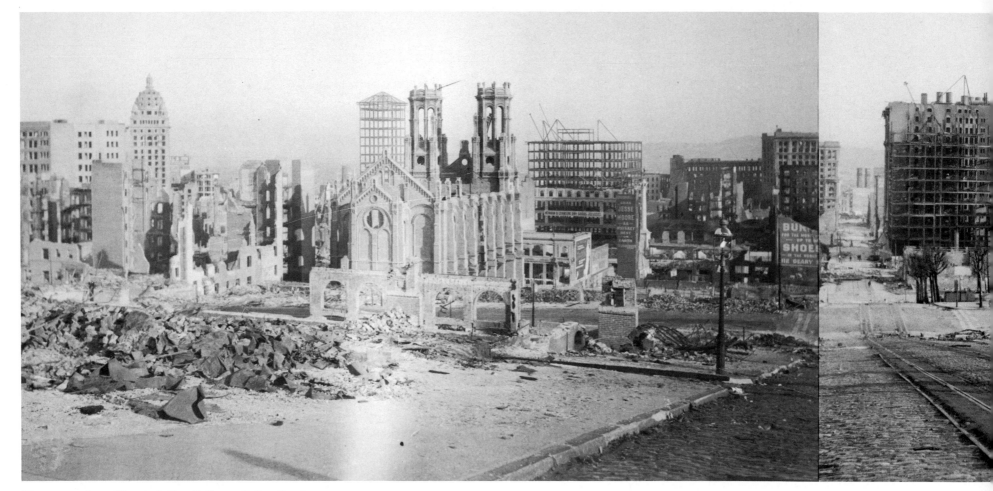

"Panorama from Pine and Powell Streets," San Francisco,
California, after the earthquake of April 1906, by an unknown
photographer. On the morning of April 18, 1906, an enormous
earthquake destroyed most of the city, killing 452 people.

RG 77, Records of the Office of the Chief of Engineers (77-AB-30-94, 95, 96)

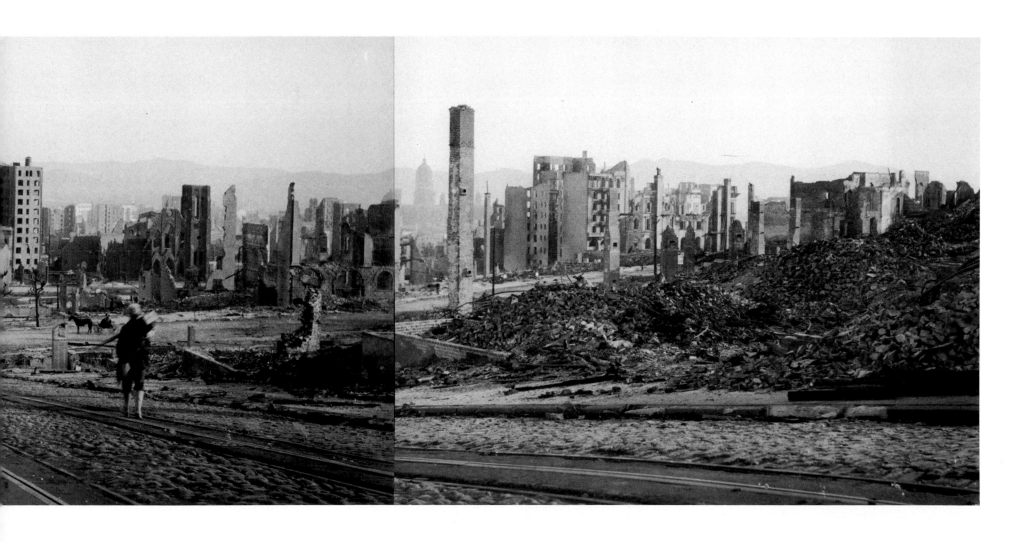

"Western Service, Wendover, Utah," April 14, 1948, by Teen Becksted. After World War II the increased mobility of Americans allowed more tourists to visit the West. The need for service stations, restaurants, and motels also brought money and growth even to small towns along the way west.

RG 306, Records of the U.S. Information Agency (306-PS-49-5674)

"Hamilton—this ghost camp yielded forty to 50 million dollars in gold before it was abandoned," Nevada, ca. 1935, by an unknown photographer.

RG 69, Records of the Work Projects Administration (69-GU-2491-c)

"Odd Fellows Hall in De Beque. De Beque, like other small towns in the Piceance, is barely maintaining itself. Departure of small ranchers and failure of the shale oil industry to materialize has made quasi-ghost towns of many of these communities. Near Rifle, CO," July 1973, by David Hiser.

RG 412, Records of the Environmental Protection Agency (412-DA-10196)

"Site of future single family homes, scheduled to open in 1976, is shown near Newport Beach, California. Development will be a part of a new town with high value planned units in contrast to uncontrolled private subdivisions." May 1975, by Charles O'Rear.

RG 412, Records of the Environmental Protection Agency (412-DA-14983)

Nature's Managers

THE WEST'S SPACE, climate, mountains, minerals, wildlife, forests, and water have made for much more than a spectacular backdrop. They have shaped the region's settlement, economic growth, and politics. Traditionally, the region's economy has centered on agriculture, ranching, fishing, mining, oil, and timber. In more recent times, tourism—marketing the lifestyle and scenic beauty of the West— has been added to the list of its key industries.

This reliance upon nature has created a struggle to master and control the environment. Such efforts have led to conflict among westerners themselves and with the federal government over control of the West's resources and the means of protecting the environment while still fostering economic growth.

"Pineapple field," Hawaii, ca. 1927, by P. Blisker photo service.
RG 115, Records of the Bureau of Reclamation (115-SF-66)

"**Dan Lohr Ranch, 1888,**" Custer County, Nebraska, by an unknown photographer.
RG 16, Records of the Office of the Secretary of Agriculture (16-G-170-2-1)

WORKING THE LAND

LAND WAS the initial lure for many who came to the West: homesteaders, speculators, ranchers, and farmers. But once there, newcomers found that while western land was plentiful, it was a hard taskmaster. Too often the soil was poor, the climate unpredictable, and traditional farming techniques ineffective. The land could be made more productive using technology, irrigation, and fertilizers, but such solutions frequently threatened the environment or were dependent on huge and costly engineering projects.

"Turning over the first sod on homestead," Sun River, Montana, November 5, 1908, by Walter J. Lubken. Much western land that came under the plow showed little prospect for a good return.

RG 115, Records of the Bureau of Reclamation (115-JAD-176)

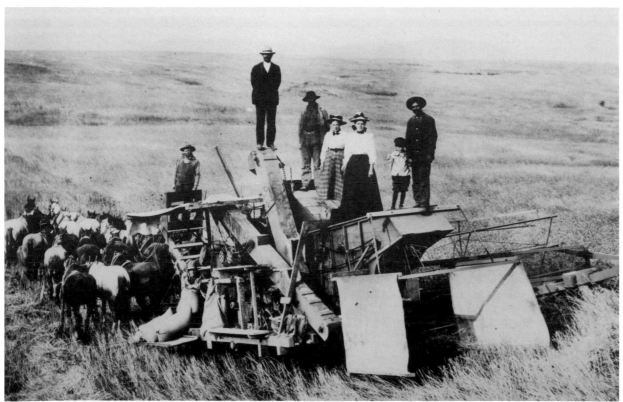

Combine, Washington State, ca. 1900, by an unknown photographer. This photograph testifies to the mechanization of farm equipment, although the machinery is still drawn by horses.

RG 16, Records of the Office of the Secretary of Agriculture (16-G-140-1-4)

Print courtesy of the Caterpillar Corporate Archives, Caterpillar Tractor Company, Peoria, Illinois

"View of back of farmbuildings, showing dust piled up on one of them, which has been caved in by the weight of the drifts. The house is still furnished but not in use." Near Winner, South Dakota, September 9, 1935, by Hutton. During World War I, large areas of the Great Plains came under cultivation. Rain was plentiful during the 1920s, but in the early 1930s the region experienced a severe drought. Huge duststorms blew across the region, darkening the sky, eroding top soil, and piling up dirt along fenceposts and near buildings.

RG 114, Records of the Soil Conservation Service (114-DL-SD5000)

EXTRACTING RESOURCES

HISTORICALLY, the West has been the nation's chief source for raw materials. The 1848 discovery of gold at Sutter's Creek in California was only the first of many natural resource booms that swept through the region. Gold, silver, oil, timber, fish, and more recently, uranium and shale oil have brought jobs and growth, but they have also raised questions about the region's dependence on industries that consume its natural resources or change its landscape and ecology.

Hydraulic mine at work, California, ca. 1884, by Clinch. Hydraulic mining, using water under pressure to dislodge the earth surrounding a mineral deposit, spread debris over the landscape. The nozzle spewed 185,000 cubic feet of water in an hour, silting streams, causing flooding, and destroying agricultural lands. This photograph was part of the evidence submitted in *U.S.* v. *North Bloomfield Gravel Mining Company,* an early federal environmental court case.

RG 21, Records of District Courts of the United States, National Archives–Pacific Sierra Region

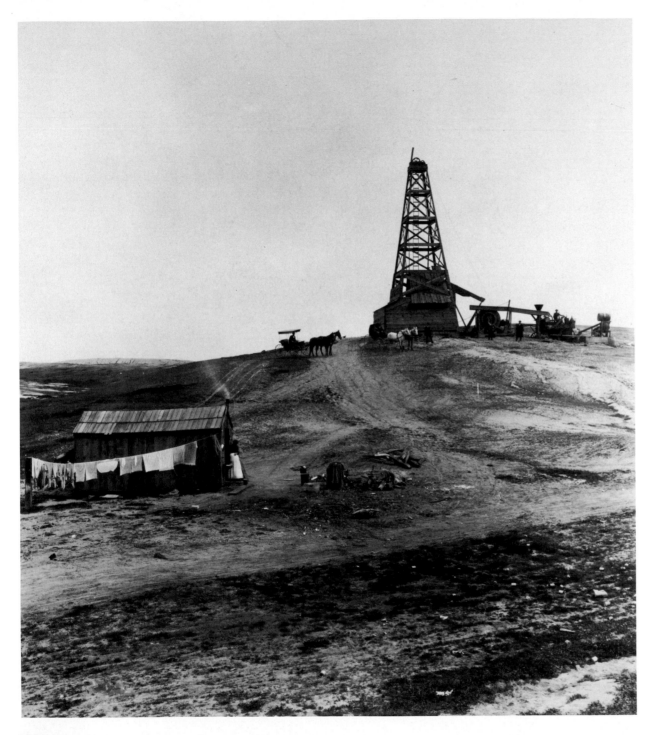

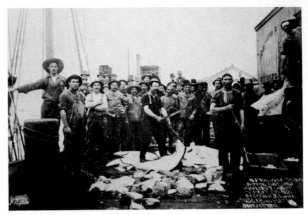

"Northern Pacific Railway, shipping first cargo of halibut caught in Puget Sounds by crew of schooner 'Oscar and Hattie.' Takoma," Washington, September 20, 1888, by N. B. Miller. From 1887 to 1893 the U.S. Fish Commission steamer *Albatross* cruised from the West Indies, through the Straits of Magellan, along the Pacific coast, and north to Alaska to collect hydrographic data and marine life. During their journey N. B. Miller, the ship's assistant naturalist, photographed this record of the 19th-century fishing industry in the Pacific Northwest.

RG 22, Records of the U.S. Fish and Wildlife Service (22-FA-197)

"Century Oil Company," Kern River District, California, ca. 1898, by Frank C. Ashton.

RG 49, Records of the Bureau of Land Management (49-KRA-2-2)

Opposite: **Loggers on a western red-cedar stump near Deming, Washington,** 1925, by Leslie R. Corbett. Photographers turned images such as this into postcards, which loggers could purchase and send to loved ones to assure them of their continued well-being.

RG 95, Records of the Forest Service (95-G-195968)

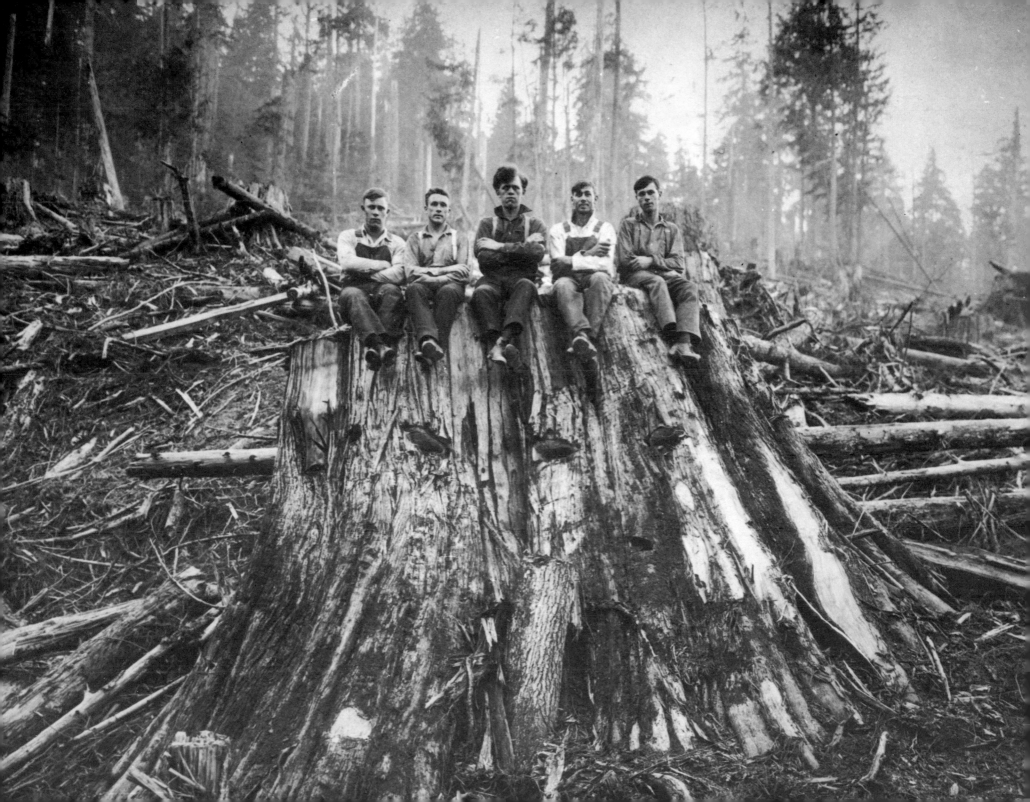

"This was not the West as I had dreamed of it. . . . It was a desolate, forgotten land, without vegetation save for the dry, crackling grass, without visible tokens of fertility. Drab and gray and empty."

Edith Ammons Kohl, a homesteader,
recalling South Dakota in the early
20th century
Land of the Burnt Thigh, 1938

"Waiting for Water. Residence of B. B. Freeman, in Sec[tion] 16, T[ownship] 2N[orth], R[ange] 3W[est] Ute M[eridian]. Mr. Freeman and family have been waiting nearly 6 yrs., having moved into this cabin in 1908." Grand Valley Project, Colorado, August 21, 1913, by H. T. Cory. Because of low annual rainfall, much of the land in the West was unsuitable for agriculture. Irrigation projects offered the promise of bringing these arid lands under cultivation and improving the lives of those who lived on "dry-land" homesteads.
RG 115, Records of the Bureau of Reclamation (115-JE-102)

NO RESOURCE is as precious to the West as water, and few factors have shaped Western history so much as its aridity. With the exception of the Pacific Northwest, rainfall drops off dramatically in the states west of the 100th meridian, and droughts ravage the region every few years. One solution to this problem was irrigation. Ancient native cultures had developed such systems, and during the 1850s, Mormon settlers put this concept into practice in Utah. By 1900 the federal government began a series of projects that eventually developed into a huge system of dams, reservoirs, and canals. Such large-scale irrigation promised to bring water from western rivers to those who wanted it and "make the desert bloom." The projects brought not only water but electric power and the promise of prosperity and growth to the towns they bordered.

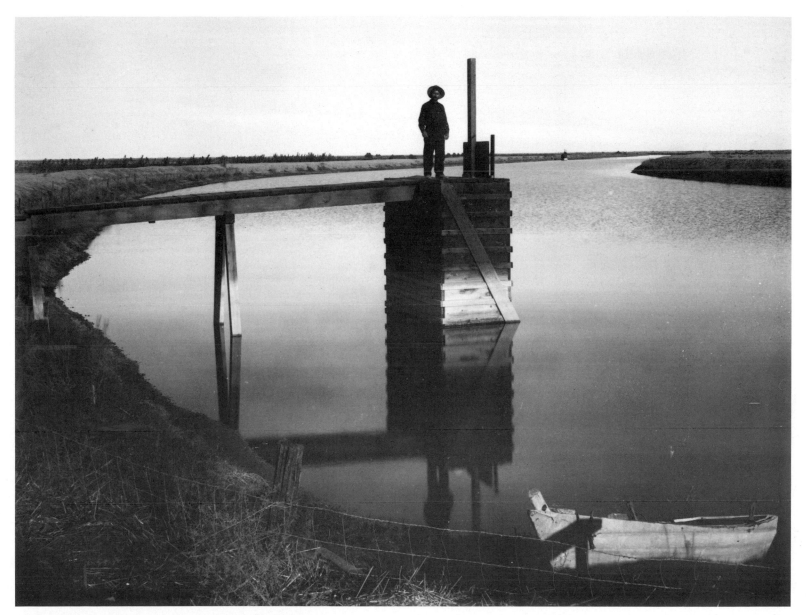

"Canal leading to Holtville power plant in Holtville California," August 31, 1909, by Walter J. Lubken. By 1905 irrigation projects in California's Imperial Valley had brought 120,000 acres of previously uninhabitable desert under cultivation. The promise of irrigated land had also brought some 12,000 new settlers to the area.

RG 115, Records of the Bureau of Reclamation (115-JI-186)

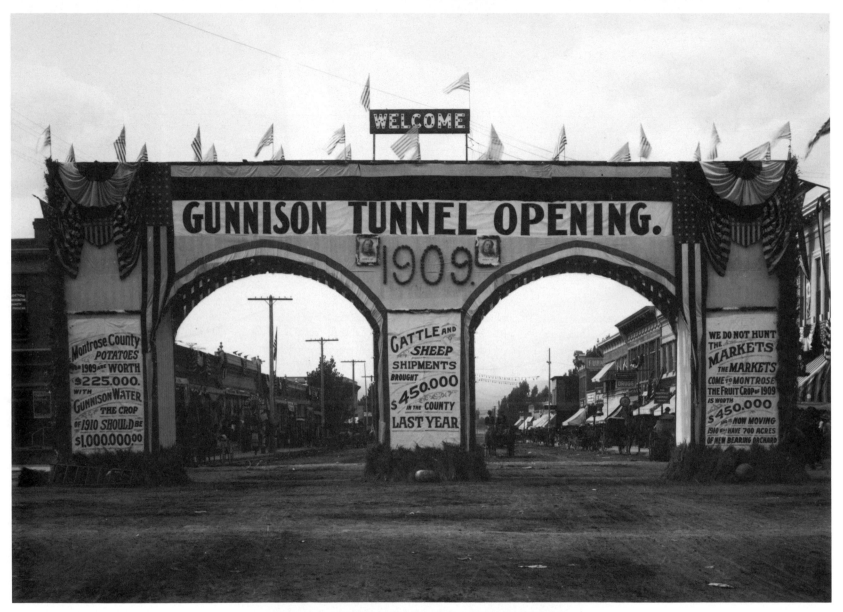

"Gunnison tunnel opening; the arch at Montrose," Colorado, September 23, 1909, by Walter J. Lubken. For towns located near irrigation projects, the opening of a canal was cause for celebration. In Montrose, Colorado, President William Howard Taft attended the event, throwing the switch that diverted water into the Gunnison tunnel.

RG 115, Records of the Bureau of Reclamation (115-JAF-604)

"The Racetrack, Death Valley National Monument, California," 1984, by Tom Till.

© *Tom Till*

DEPARTMENT OF THE INTERIOR
UNITED STATES RECLAMATION SERVICE
TRAMWAY BUILDING
DENVER, COLO.

Los Angeles, California. November 22 1919

From Homer Hamlin, Consulting Engineer.

To Chief of Construction, Denver, Colorado.

Subject: Boulder Canyon Dam Site.

1 After the conference today regarding the Owens Valley, Mono Basin Project Mr. Mathews told me that he had seen the Director in Washington, D. C. and had talked with him about the Boulder Canyon dam on Colorado River. He was greatly impressed with the power possibility at that location.

2 From what he said, I am sure you can count on his active assistance in pushing that project along. As I have said before, the City of Los Angeles needs power, all the power it can develop on it's own projects, and in addition, all within reach from other sources. I am sure the City will be an ardent supporter of the Boulder Canyon Project. All the power you can send down to Southern California will not impair the value of the plants contemplated by the City.

3 Is it permissible for me to go into this matter with Mr. Mathews? He is a man of exceptionally good hard sense and of broad vision. Ask the Director what he thinks of him.

Homer Hamlin

Memorandum from Homer Hamlin, consulting engineer, to chief of construction, Denver, Colorado, November 22, 1919. The massive dams necessary to many reclamation projects brought to the West not only water but also the promise of cheap hydroelectric power. *RG 115, Records of the Bureau of Reclamation, National Archives–Rocky Mountain Region*

"Boulder Dam, 1941 looking across water to dam," by Ansel Adams.

RG 79, Records of the National Park Service (79-AAB-4)

A QUESTION OF BALANCE

STRIKING a balance between using and preserving natural resources has always been problematic for westerners. For example, in the early 20th century the West encouraged tourism, and as tourism increased, so did the need for support industries. But as these industries grew, they threatened the very beauty that tourists came west to enjoy. The challenge of balancing such interests continues today. Timber and mining are also key western industries. Restricting timber cutting or opening new mines may cost jobs, but loosening regulation may damage the environment and therefore hurt tourism. In the American West such dilemmas take on great immediacy. They also raise the issue of whether "conservation" means leaving nature alone or "managing" it with human purposes in mind.

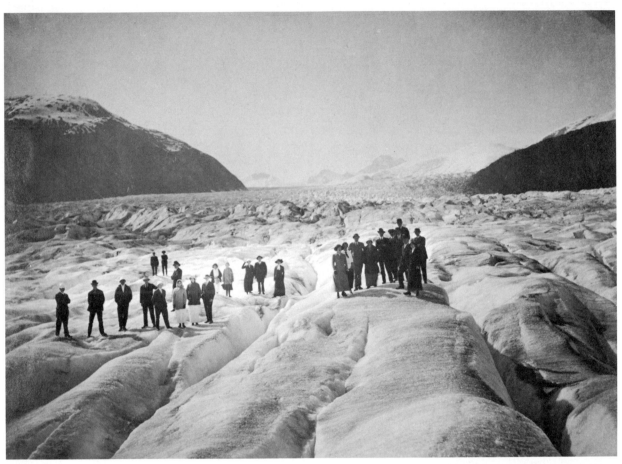

"On the Great Glacier. Stikine River near Wrangell, Alaska, June 21, 1914," by J. E. Worden. By the early 20th century, tourism was a growing segment of the West's economy. Even remote parts of the West like this Alaska glacier were becoming popular attractions for adventuresome travelers.

National Archives Donated Materials, Henry S. Wellcome Collection, National Archives–Alaska Region

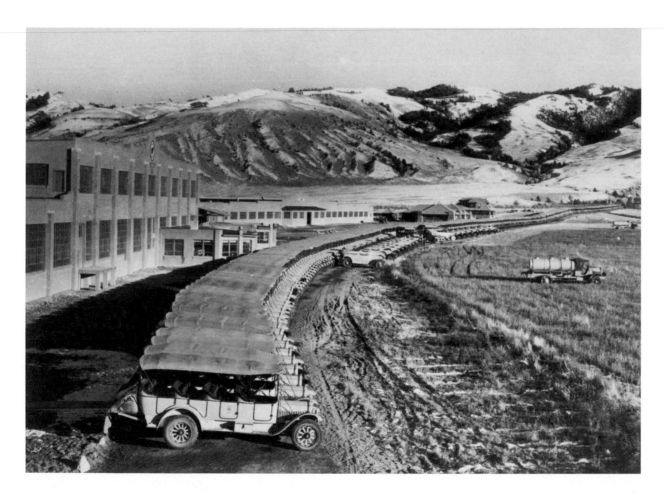

"Beauty of Yellowstone meets practical needs for modern transportation of growing numbers of tourists," Yellowstone National Park, Wyoming, ca. 1924, by Jack Haynes. As photographic concessionaires in Yellowstone National Park, Jack Haynes and his father, noted frontier photographer Frank J. Haynes, took thousands of photographs of Yellowstone over a period of some 70 years.

RG 79, Records of the National Park Service (79-G-31-131)

"United States Department of the Interior, Office of National Parks, Buildings and Reservations The Master Plan for Mount Rainier National Park, 1936 Coordinated by the Branch of Plans and Design, Fifth Complete Edition," by an unknown artist. As tourism increased, so did tourists' expectations of facilities such as transportation, food, and lodging. "Master Plans" allowed the National Park Service to map out areas to accommodate the needs of large numbers of visitors with the least disruption to the integrity of the park.

RG 79, Records of the National Park Service

"Clear Cutting," northern California, May 1972, by Tomas Sennett. Clear-cut timber is usually harvested in 40- to 60-acre "patches." The timber industry remains a major employer in the West, but in recent years there has been controversy over harvesting in old-growth forests and over the effect of lumbering on the ecology of forest wildlife.

RG 412, Records of the Environmental Protection Agency (412-DA-347)

Drought-parched grapevines near Bakersfield, California, 1990, by George Wuerthner. In the late 1980s California faced several years of severe drought. Low water levels in California reservoirs caused widespread water rationing and crop loss. Some environmentalists argued that the region could no longer sustain the huge population, irrigated agriculture, and urban sprawl typical of modern southern California.

© *George Wuerthner*

"Pipeline, Alaska Range south of Delta Junction, Alaska," 1983, by George Wuerthner. Stretching over 800 miles, the Alaska oil pipeline was the largest private construction project in history. It was preceded by controversy over the pipeline's effect on wildlife and on the Alaskan wilderness as well as arguments over U.S. energy needs and the impact of the project on Native Alaskans.

© *George Wuerthner*

"Burned Area, Glacier National Park," pine trees, snow-covered mountains in background, Montana, 1941, by Ansel Adams. In 1941 the Interior Department commissioned Ansel Adams to photograph the West for a series of murals for the Interior Building in Washington, DC. The murals were never done, but over 200 of Adams's photographs were later added to the holdings of the National Archives.

RG 79, Records of the National Park Service (79-AAE-3)

Opposite: **"The Tetons — Snake River,"** Grand Teton National Park, Wyoming, 1942, by Ansel Adams. Ansel Adams's photographs of the Western United States testify to the region's beauty. Adams and other conservationists used his powerful imagery to argue that the West's wilderness was an irreplaceable national resource and a source of spiritual and psychological rejuvenation.

RG 79, Records of the National Park Service (79-AAG-1)

For Further Reading

Athearn, Robert G. *The Mythic West in Twentieth-Century America.* Lawrence: University Press of Kansas, 1986.

Fleming, Paula Richardson, and Judith Luskey. *The North American Indians in Early Photographs.* New York: Dorset Press, 1988.

Lamar, Howard R., ed. *The Reader's Encyclopedia of the American West.* New York: Thomas Crowell Company, 1977.

Limerick, Patricia Nelson. *Legacy of Conquest: The Unbroken Past of the American West.* New York: W. W. Norton, 1987.

Luchetti, Cathy, and Carol Olwell. *Women of the West.* Berkeley, CA: Antelope Island Press, 1982.

Nelson, Paula M. *After the West Was Won: Homesteaders and Town Builders in Western South Dakota, 1900–1917.* Iowa City: University of Iowa Press, 1986.

Paul, Rodman W. *The Far West and the Great Plains in Transition, 1859–1900.* New York: Harper and Row, 1988.

Trachtenberg, Alan. *Reading American Photographs: Images as History, Mathew Brady to Walker Evans.* New York: Hill and Wang, 1989.

Udall, Stewart, Patricia Nelson Limerick, Charles F. Wilkinson, John M. Volkman, and William Kittredge. *Beyond the Mythic West.* Salt Lake City: Peregrine Smith Books, 1990.

Viola, Herman J. *After Columbus, The Smithsonian Chronicle of the American Indians.* Washington, DC: Smithsonian Books, 1990.

———. *Exploring the West.* Washington, DC: Smithsonian Books, 1987.

Worster, Donald. *Dust Bowl: The Southern Plains in the 1930s.* New York: Oxford University Press, 1979.